how to start a home-based

Wedding Photography Business

how to start a home-based

Wedding Photography Business

Kristen Jensen

gpp®

Guilford, Connecticut

Editorial Director: Cynthia Hughes Cullen
Editor: Tracee Williams
Text Design: Sheryl P. Kober
Layout: Sue Murray
All interior photography by Kristen Jensen

ISSN 2164-2206
ISBN 978-0-7627-7341-1

Printed in the United States of America
10 9 8 7 6 5 4 3 2 1

To my son, Noah, for giving me the courage and strength to persevere and to never give up my dreams.

Contents

Acknowledgments

I'd like to thank Kai-Lin Black for all her help and Mona Klepp for helping me start, build, and run the business side of my company. I also would like to thank Sarah Bouissou, owner of Bernard's Restaurant in Ridgefield, Stephanie Pellitier, former director of the Ridgefield Community Center, and all my other friends and colleagues in the wedding industry, who believe in my artistic abilities and have helped build my business to what it is today.

Introduction

In recent years, working from home has become more popular as well as more convenient. Technological advances have opened up many doors and helped create more positions for people looking to work out of their homes. If you would like a flexible work schedule, want to avoid long commutes, and want to be your own boss, working from home could be the right decision for you.

A home-based wedding photography business is an easy choice for those who enjoy being creative and have a passion for taking pictures. Photography businesses are one of the most suitable choices for those who want to work at home for a few reasons, the first being small start-up costs. For those who already have decent equipment and editing software, start-up costs can be practically nonexistent. For those who do not, the start-up costs are relatively low compared to other home businesses. Another reason is because weddings are always going to happen, no matter the financial climate.

Choosing to become a professional photographer was life changing for me, since choosing to work from home was a necessity. When I found myself with a three-month-old baby to support and no income, I turned to my longtime hobby, photography. I realized that I could make a living doing something I absolutely loved while also being home to take care of my son. My home-based wedding photography business has flourished and provided me with financial stability, wonderful clientele, and the experience of a lifetime. I never would have guessed that photography could be so rewarding. If I had to go back and do it all over again, I would in a second.

Being a professional photographer with a home-based business is a unique lifestyle. There are many great things about running a business out of my house—too many to count. Throwing photography, a lifelong passion

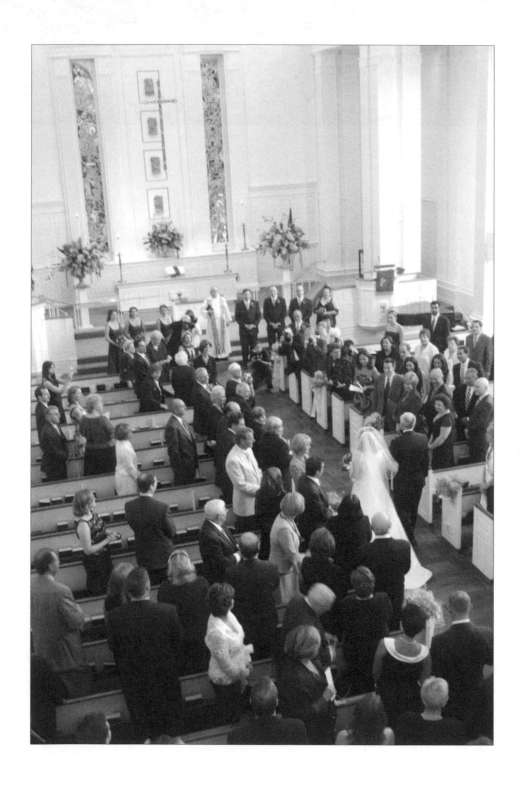

of mine, into the mix made this profession perfect for me and my way of life. Being able to do what I do is a dream come true.

This book will help you become a wedding photographer, leading you through every step of the process. Although some steps can be complicated, I have organized my personal experiences and tips from the beginning, when I was first starting out, to the present, as an established photographer, creating an easy-to-follow guide for you to use. I have been in a lot of different situations where I had to think quickly on my feet, and I have included them in the book to help you if you run into a problem that may be similar. Using the situations I have been in, you can begin to reason through any dilemma you might face.

This book will also assist you in learning how to make smart business decisions as a home-based photography business owner. I hope that you will use my book as your go-to guide when you have a question or need advice about starting your own wedding photography business.

For those of us who consider ourselves photographers, photography usually starts out as a hobby. Photography can be a versatile skill for those who pursue it— it is something that can morph from just a pastime to a successful business done right out of your home. There are many different types of photography: nature, fashion, underwater, portrait, editorial, and product, just to name a few. Wedding photography differs from the other branches of photography because it focuses on a one-time event, and you can't go back and reshoot.

This means that a wedding photographer must be prepared for a mix of literally the best and the worst that can happen at any given time. This could mean that it starts raining in the middle of a shoot, or a member of the wedding party is late. Whatever the case, a wedding photographer has to be ready and extremely prepared in order to avoid chaos, keep everything on track, and still get all the shots required. You need to be prepared both mentally and technically. Mentally you have to be prepared to make every single guest feel at ease in order to get the best photos. You also need to be prepared technically. In other words, you need to feel ready enough to take on any given situation.

I remember shooting a wedding where the reception was set up in a tent but the bride and groom forgot that they would need to also set up a dance floor. Every guest had mud up to their knees and I felt technically prepared to get shots where their feet didn't show and I could hide the fact that the bottom half of everyone was a mess. I remember another situation when I shot during a heat wave and there were no fans and no air conditioning. I had to deal with hot, sweaty guests and make them look good. On the other hand, I shot a wedding during Hurricane Katrina and there was no electricity. The

only light was provided by dimly lit candles, and I could hardly focus my cameras enough to take pictures. In any given situation, wedding photographers have to be as prepared as they can because anything can happen.

Although being a wedding photographer can be exceptionally stressful, there are many ways to alleviate this pressure. Planning ahead, making checklists, and communication are just three examples of the many ways you can be a reliable wedding photographer.

How I Got Started in the Business

Photography has been a big part of my life, although when I was younger I never would have guessed that I would grow up to be a professional in this field. I started modeling after high school, when I met a photographer at a beauty contest my mom had entered me in. He encouraged me to pursue modeling because he thought I could make it and had the right look. I also tried acting, and I spent my young adulthood living in Europe, New York, and Los Angeles. I was a FORD international model and spent all of my time in front of the camera. It wasn't until I moved to New York in my late twenties and started taking photography classes at New York University that I switched sides and became the one behind the camera. I had many professional photographer friends and I would pick their brains about their profession. Even though it was something I gravitated toward I didn't consciously think I could ever make it. Thinking about the technical side of photography made me want to run for the hills.

Even though my mother did interior design and traveling around the world had opened my eyes to the beauty of art, I still did not feel confident that my interest in photography could turn into anything but a hobby. Looking back now I realize that even at a young age I had an eye for light and a good sense of aesthetics and composition. After traveling around Europe and opening my eyes to more and more art, I started to unconsciously train my eye to have a point of view. I also started developing my own style and began noticing the use of light all around me. Being a model also helped develop these skills because I was constantly around cameras and lighting. The saying that "beauty is everywhere" really began to ring true with me. I realized that observing ordinary things day to day is important because beauty is everywhere; you just need to see it that way.

I started photographing other models while we were on a shoot together. If we were just standing around waiting to be photographed, I would take out my camera and start taking pictures. I think that this helped me develop skills early on that

would benefit my career as a wedding photographer later on in life. I'm lucky that I was able to work with such talented people, who knew how to be behind a camera. You can practice on friends and people you know as well, to get practice like I did. Just getting out there and taking pictures can really help you. Producing a video on how to become a model, entitled "The Art of Modeling," was what really pushed me to pursue photography as a profession. I also wrote and directed the video, but being behind the camera was what I liked the best, and where I felt the most comfortable. This was my calling to become a photographer.

Making the Decision to Become a Wedding Photographer

Starting your own wedding photography business may not be easy, but making the choice to do so can be simple. The wedding photography business is not for everybody. There are different characteristics of the job that are required but that might not fit your lifestyle. There is a lot of competition in this industry, but fortunately people are always getting married, no matter what the financial climate might be. Advances in technology and the Internet also make aspects of the job easier and more fun. I think that creating my business was the best thing I have ever done. I get to do what I love, work out of my home, and meet a lot of amazing people. Putting in long hours and working some weekends is not always easy, but it is always rewarding.

There are a lot of different things you need to take into consideration before deciding to become a wedding photographer. No one but you can decide if creating your own wedding photography business would be something you could succeed at, but there are certain indicators to help you come to the right conclusion. If you are considering becoming a professional wedding photographer, there are some things you need to keep in mind before jumping in headfirst.

What Qualities Make a Good Wedding Photographer?

There are six main qualities that I think a skilled wedding photographer must possess in order to succeed:

- Be a people person
- Be technically confident and on top of your game
- Be able to think quickly on your feet
- Be able to think spontaneously in order to grab shots

- Be able to work well under pressure
- Be a leader and take charge of a situation

Here are some other important qualities I think you will need to possess to succeed on the business side of this profession:

- Be organized
- Be punctual
- Have good communication skills

How Do You Know If Wedding Photography Is Right for You?

Ask yourself the following three questions:

Question 1: Why do you want to be a wedding photographer?

This seems like a simple question, but answering as honestly as you can is key. Coming up with a list might help. If you're still stuck, try making a list of pros and cons. The pros could be why it would work and the cons could be why it wouldn't work. This method helped me; my "pros" list was a mile long.

Question 2: Are you a people person?

This is one of the most important questions to ask yourself because it is so essential to be extroverted in this field. I was never a people person growing up but that changed once I became a wedding photographer. I've learned that you have to be able to speak up and not be shy. At the end of the day, you have to get the shot. If you don't say something, you won't get it.

Question 3: Do you want to work weekends?

A lot of weddings fall on weekends so it is necessary to be able to work them. Unfortunately that is the nature of this business. It is something you have to consider. I consider a wedding to last between nine and eleven hours; that's a whole day on a weekend. If you're not willing to work weekends, wedding photography might not be for you . . . unless you live in Hawaii. Photographers who live in Hawaii can shoot weddings seven days a week.

Wedding photographers who live in vacation destinations and warm climates typically are able to shoot any day of the week. Couples very often opt for a destination wedding because of the flexibility and romance that this type of wedding location has to offer. I have worked with couples that have flown both my assistant/second shooter and me to the destination, which was really awesome. But wedding photographers who live and are based in places like Hawaii and the Caribbean have

the opportunity to shoot more weddings because they can happen any day of the week. Many photographers try to market themselves as a "destination wedding photographer" and they succeed at getting booked on weddings at amazing places. There are wedding planners who specialize in this area and they would be the best type of people to network with if that is what you want to do.

What to Consider When Starting Your Own Business Checklist

- ❏ Do you have a self-disciplined and entrepreneurial spirit?
- ❏ Are you goal- and task-oriented?
- ❏ Are you a "people" person?
- ❏ Do you like working five days a week, and then on weekends and evenings too?
- ❏ Do you have the skills and confidence in your craft as a photographer?
- ❏ Do you have the right equipment (with enough as backup)?
- ❏ Do you have the "right" computers and hard drive space?
- ❏ Do you have a set amount of start-up marketing funds, which can cover website design, search engine optimization (SEO), direct marketing, business cards, and albums?
- ❏ Do you have a business plan?
- ❏ Are you able to meet and consult with an attorney?
- ❏ Are you able to negotiate client contracts?
- ❏ Are you able to financially weather the fact that weddings are typically a seasonal business?
- ❏ Are you a flexible person who can handle the overall stress of your clients on their wedding day?
- ❏ Are you a talented photographer who can handle any lighting situation at a moment's notice?
- ❏ Can you handle the fast pace of a wedding day?

Seasonality: Full-Time versus Part-Time

Depending on where you live, wedding photography can be a full-time or part-time job. If you live someplace like Hawaii, where weddings tend to be extremely popular and go all year-round, it is definitely possible to be a full-time wedding photographer. However, for the rest of us, being a wedding photographer is usually seasonal, occurring between the months of April and November.

But there are ways to be a home-based wedding photographer and have a steady income all year long. For one, you can branch out like I did and become an events photographer, photographing different types of events all year long (see chapter 13, Shooting Other Types of Events). Another way to keep a steady income all year is to be a freelance photographer for a local newspaper or magazine. My advice would be to look online at local newspaper and magazine websites around your area to find out if they need freelance photographers and if the job pays. If you save during your busy months, you can figure out a way to take a pay cut during the slow months and freelance. Another option could be to find a winter job that interests you to pay the bills while the wedding season is slow. There are many ways to work around the fact that wedding photography can be a seasonal job, depending on where you live. You just need to be creative and think ahead.

The reason being a wedding photographer is so great is because you decide how many weddings you are going to book for the year. You can decide to be more full-time or part-time depending on the circumstances in your life. For example, I have a son so I don't book as many weddings as I could during the busy season because I still want to have time for him some weekends. If you have kids or have another

Deciding to Go Full- or Part-Time

When I first started my business I was still doing modeling jobs on the side to pay for living expenses. If you're starting a home-based wedding photography business but are still employed somewhere else, my advice would be to stay with that job until your business takes off. It's best to go slowly and not quit your day job right off the bat. Keeping your day job will ensure you still have an income to pay for your living expenses and hopefully to start a savings account for your wedding photography business.

part-time job you'd like to hold on to, wedding photography can be very flexible. I would suggest, from the start, that you decide whether you want to book as many weddings as you can or only one or two per weekend. I think it is important at this stage to set goals for yourself, because this helps you have something to look forward to and you can be clear about what you want to accomplish. Write down a list of at least three goals and give yourself a reasonable amount of time to accomplish them. Don't beat yourself up if you hit a rough patch; keep pushing ahead because it will be worth it in the end.

Gaining Experience and Building a Portfolio

I really lucked out when I was first starting out because three of my good friends got married, and two of them were fellow models. This helped me immensely because it helped me to build a really great portfolio. Having beautiful people in my photographs for my portfolio was what got me my first paid shoots. My photographs were so great, mostly because of the people who were in them. I was also lucky with the locations of my first weddings. It makes a huge difference in your photos if the location is scenic. When you're starting out and a great-looking couple comes to you to shoot their wedding, and/or you have the opportunity to shoot at an outstanding location, do it. It may sound shallow but it will really help your portfolio. Remember, if you don't have experience you'll have to shoot the wedding for free or for a minimal fee, until you get established.

Experience Is Key

Try to assist or "second shoot" as many weddings as you can. Assisting a photographer can be helpful for the first few times you work a wedding. Assisting is a good way to get the flow of weddings down and see how fast-paced they are. After you feel comfortable, try to second shoot with an established wedding photographer. Second shooting is being the second camera at a wedding. You don't necessarily have to get all of the mandatory shots, but a second shooter is still extremely important. A second shooter is responsible for getting all the shots the first shooter can't. This is good experience because all the pressure is not on you, but you still need to use your initiative and think quickly on your feet. It is important to get this type of experience so you can recognize the flow of weddings and see how quickly they go. The more you second shoot, the more comfortable you will be, so that when it's your turn to be the main photographer, you're prepared.

After shooting everything you can think of, you will need to start building a portfolio with a selection of your photos. It is extremely important to have an impressive portfolio. This is a very competitive business and in order to book jobs, you need to have a solid portfolio. A good portfolio is one of the most important things to have for any type of photographer, but especially for wedding photography because it showcases your work to prospective clients. Without an impeccable portfolio it is impossible to make it as a wedding photographer. Second shoot as many weddings as you can to build your own portfolio. Ask the established photographer prior to second shooting what his or her policy is on using the wedding photos you shoot for your own publicity.

How to Find Jobs Assisting and Second Shooting Weddings

Finding a job is never easy and getting a job as a photo assistant or second shooter is no exception. The good news is that once you book your first few jobs it gets easier from there. Second shooting or being an assistant at an event/shoot is a great way to network and meet established photographers. This is the second reason these jobs are so important. The first and most important reason is to gain experience.

The first way to look for these jobs is on the Internet, because of the convenience and the simplicity of it. There are a lot of job boards on the web that are free and easy to navigate. One of my favorites is Indeed (www.indeed.com). This site is really great because when you search for key words like "photography" and "assistant" it searches through all job sites and compiles jobs into one search result. Another good site to keep in mind is Craigslist (www.craigslist.com). I like this site because you can narrow your search to a city and state, which is an easy way to weed through results that are relevant to you based on your location. Sometimes the best way to search these sites isn't by using specific keywords together like "photography assistant" or "second shooter" but to do one big search of "photography." I have found that this yields much better results than being too specific.

Another way to find these types of jobs is to make yourself known to established photographers in your area. Do an online search of photographers in your location and write down the first twenty-five names that pop up. After you make a list, start at the top and go to each photographer's site. Write notes on a pad of paper about what you like about the site, something you admired about the photographer, things you didn't like, whether you liked their style, or if something catches your eye in general. This is a good way to distinguish between all of them for future reference.

After going down the list, narrow it down to about ten to fifteen photographers that you feel you would get along with the best and learn the most from. Since the most important reason you want to be a second shooter is to learn, you want to make sure you work with a photographer you think you can learn valuable lessons from. Once you have a list of between ten to fifteen names, call or e-mail all of them and introduce yourself to each and every one. I know this seems like a daunting task, but it will show that you have initiative. This can set you apart from other up-and-coming photographers that might be contacting them.

I always recommend calling but nowadays, e-mailing is acceptable as well. Whichever way you choose, make it brief. I suggest introducing yourself and telling the photographer that you are looking for extra work and to gain experience. Keep it short and sweet, because if they are interested and need help, they will contact you. That would be the time to ask questions or answer any of their questions. If you decide to call, make sure there is no background noise and write down on a piece of paper what points you want to get across so you don't forget in the moment. If you choose to e-mail, you can draft an e-mail that you can use for all ten photographers. Just make sure you personalize it, and change the name for each one.

The best way to go about finding work is to do both types of searches. Look on online job boards, and do a search of established photographers in your area. Apply to or contact as many as you can; the more job experience the better. Never turn down a job, even if it isn't paid and you need the money. The experience that you will gain will be worth it and it can very well lead to second shooting jobs in the future that will be paid.

Your Portfolio Is Essential

When building your photography portfolio, sometimes it is necessary to have more than one. You might have one for your landscape photography, one for corporate portraits, and one for your wedding images. Different portfolios are useful to separate themes and be more organized, but it's up to you. The important thing to remember when creating your portfolio is that there is no right or wrong way to do it. You just need to be creative. A portfolio must show your best work to clients, so keep that in mind when selecting the photos to go into it. It is better to have fewer photos than too many, or even one image that is not top-notch.

The first step in creating a portfolio is to think about who your audience is. Wedding photography portfolios need to have a wide range of photographs to show how

What Pictures Should Go in Your Portfolio

- **Beauty shots** (think of the kind of pictures that would go on the cover of *Modern Bride*)
- **Full-length shots** (full-length of bride's dress)
- **Environmental shots** (getting ready)
- **Still lifes** (dress, centerpieces, invitations, flowers)
- **Candids** (tight headshots of people laughing)
- **Full landscapes** (whole area outside the venue, full shots inside the reception area or church)
- **Engagement shots** (more of an editorial feel; shot outdoors)

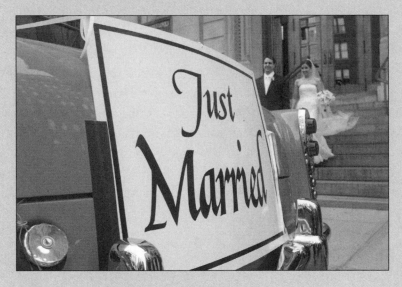

(See appendix A for inspiration in creating your portfolio.)

versatile you can be as a photographer, because each client will like a different style. I like both color and black-and-white photography, so I might use a mix of both in a portfolio I show to prospective clients to show that my photos look great either way.

It might be helpful to start out by deciding what the purpose of creating a portfolio is. That way, when you're done putting your portfolio together, you can be the judge and say whether you succeeded in achieving your goal.

It's important to make sure the pictures in your portfolio are varied. Make sure you have pictures showing the use of different lenses. Also make sure you don't have pictures from just one location or just one bride.

Another way to build and expand your portfolio is to do complimentary engagement photos, tabletop sessions for wedding venues, and bridal/tuxedo shop photos. Beauty shots of a bride that has just had her makeup done are great additions as well. Try shooting this for the makeup and/or hair artist. Offering tabletop sessions for wedding venues or working for any wedding vendor can also benefit your business by advertising for them while helping you build your portfolio.

My wedding portfolio is an online presentation of a selection of my photographs. I also have about a dozen different styles and sizes of wedding albums to show prospective clients. I like having a digital portfolio because you can virtually show your work to anyone without having to meet with him or her. It is not only more practical but often more convenient for both the client and myself.

My website is www.kristenjensen.com, and it has my online portfolio for prospective clients to see. It is important to have an online presentation featured on your website for those clients who do an online search and end up on your site. See chapter 5 for more about setting up and designing your wedding photography website.

Separate Yourself from the Rest

I create books (aka albums) for my clients that include graphics and text to enhance the photos and tell a story. Each one is entirely customizable, which attracts couples to them. Each one is different and unique. I once did a book that included all Dave Matthews Band lyrics. For me, these books make up about 50 percent of what clients like to do with their wedding photos. Having an option like this is important because it gives clients a variety of choices for what to do with their photos. The books are also nice to show prospective clients because they're kind of like individual portfolios. The books draw them in, since not every wedding photographer does it. If you can think of an alternative like this for your own wedding photography business, I'd very much encourage it. Having something exclusive to offer in this line of work is a plus for clients. I have a photographer friend that is offering the couples wedding photos digitally on an iPad. Pretty cool, huh?

How to Differentiate Yourself from Other Photographers

I have marketed myself as unique because of my past experience being in front of the camera. Having a modeling background has helped me because I can play on the fact that I understand what it is like to be photographed and know what type of angles work best. I also have played on my vast experience traveling and working with a ton of different people, locations, and all sorts of lighting situations.

The way to differentiate yourself from other photographers is to choose what you think is a unique aspect of your photography or yourself and play into how it greatly affects and makes your business better than the rest. An example is destination wedding photographers. They differentiate themselves by marketing to couples that want to get married in romantic getaway locations. By catering to this need, destination wedding photographers play into the fact that some couples want to get married in a Caribbean-type location and limit themselves to only doing these types of weddings.

Finding a way to distance yourself from the rest of the pack doesn't have to be as extreme as being a destination wedding photographer. The key is to find something special about your photography that benefits you as a wedding photographer and use this to market yourself and differentiate yourself from other wedding photographers.

Deciding What the Next Step Will Be in Creating Your Business

While all this preparation might seem stressful, it is also relatively easy because you get to do what you love while working out of your own home. Starting your own wedding photography business may seem like a daunting task, but when you have the right equipment and skills the only thing you'll need is a ton of motivation!

Along with motivation, you also need a plan. It is always better to plan ahead. If need be you can deviate from that plan and create a new path. But it is hard to have no plan and "wing it," so to speak. If you want to succeed in running a business out of your home, you need to get a lot of advice and suggestions as to how to go about doing it. Now is the time to do your homework and do a lot of research. You don't necessarily need to map out every aspect of your business at this time, but you want to have a vague idea of all the details in order to plan.

I would suggest keeping a notebook and jotting down any information you come across that will help you create a business plan. The notebook is also a good place to sketch logo designs or begin to lay out how you want your website to look. Although these things might not necessarily be in the picture yet, they will be eventually. A notebook is a good way to stay organized and keep your thoughts about your business plan all in one place.

Another thing that is helpful at this stage is to come up with a flexible timeline in which you can jot down things that need to be done and in what amount of time. For example:

- Second shoot for a photographer—one month
- Start creating a portfolio—six months
- Think of a domain name—one year
- Start setting up a home office—one year

Coming up with a list of things that need to be done and putting them in the logical order in which they should be done can keep you organized and help you to stay on task. Having a vague idea of a business plan is the best way to get the ball rolling and really start your new business.

Your Equipment and Mastering Digital Workflow

Now that you've decided you want to pursue a career as a wedding photographer, you need to obtain the proper equipment and establish a digital workflow system that works for you. Because there are different brands of equipment and computers to choose from, there is no set standard as to what every wedding photographer uses. Each individual photographer might mix and match brands to his or her own liking. There is no right or wrong as long as you have the appropriate equipment to take spectacular pictures.

Choosing Your Camera and Equipment

After I made my list of pros and cons, I really got to thinking about seriously trying my hand at professional photography. I made it my New Year's resolution to chase my dream of becoming a wedding photographer, so I went out and bought the best equipment I could get. I chose digital because it was new on the market and no one else had it. For the next six months I became familiar with my new gear, and I photographed every single person, business, and wedding I could for free.

Since there are so many different brands to choose from, it can be hard to choose the "right" equipment. But I don't believe in the "right" or "wrong" equipment. As long as you have professional quality equipment that is reliable and can produce high-quality photographs, it doesn't really matter what brand you choose. I know there are a lot of options out there, so I have narrowed some of my favorites down for you to look at to help guide you in the buying process.

Types of Cameras

I have two Canon EOS 5D Mark II SLR camera bodies. Three other very good cameras are: Nikon D3, Olympus E-3, and Sony a900DSLR. Like I have mentioned before, cameras are a matter of personal preference. The best advice I can give is to try different brands and see which ones you like the best. The only thing you need to make sure is that you are happy with your choice because it is an investment. Because these are specialty cameras, you cannot find most of them in stores unless it is a photography store. Go online to compare camera reviews and to purchase one.

Types of Lighting

Selecting lighting gear is generally like picking a camera—which brand do you like the best? I recommend Photogenic, which is what I use. I also recommend Photoflex and ALZO Digital. When you second shoot, take note of the types of lighting that the photographer uses and whether you like it or not. I would recommend buying all of your lighting equipment online for convenient delivery.

How to Protect Your Lenses/Equipment When on the Job

The three main reasons you need to protect your equipment:

- It is your livelihood and how you make an income.

- Your equipment will last longer.

- Less value will be lost if you decide to sell it to get newer equipment.

The best way to protect your camera is to have the right camera bag. It is all about trial and error here. You most likely will switch camera bags from year to year until you realize what works for you and what doesn't. A camera bag is a total matter of preference. However, make sure the one you choose is durable and good quality.

You can also buy a camera screen protector so it doesn't get scratched. These range from about $2 up to $20 on Amazon (www.amazon.com). You might want to consider purchasing a camera "skin," which is a tight case that you put around your camera to protect it from dust, rain, snow, or other weather conditions. You can find a range of these at Camera Armor (www.cameraarmor.com). These three items will help preserve your camera's life and can help you save money in the long run.

You might also consider buying UV filters for your lenses, which cost about $20. These help protect your lenses from getting scratched and block UV rays when shooting on sunny days, which prevents your pictures from being discolored. You can find these at Camera Filters.com (www.camerafilters.com). The final thing you want to think about is card cases to hold all of your memory cards. Since these cards are so small and sensitive, dust or dirt can settle into their crevices, resulting in a faulty media card, which can be a disaster. You can find cases online at B&H (www.bhphotovideo.com). I highly recommend spending the extra money to protect your equipment because as a wedding photographer, it is unacceptable to have damaged equipment if it could be avoided.

Types of Lenses

You will need a variety of different lenses—about three to five to start. The first lens I would suggest is a 24-70 mm lens, which is a standard zoom lens. A fisheye lens allows you to shoot extremely wide-angle shots and gives a unique distorted look.

An 85 mm lens is a telephoto lens that is used for natural light photographs. A 7200 anamorphic stabilizer lens is ideal for the reception and aisle shots. The last lens I would recommend for weddings is a 105 mm macro lens, which can be used for detail shots and portraits. All lenses can be bought online at sites like www.amazon.com, www.canon.com, or www.nikonusa.com.

Types of Media Cards

After trial and error, I have found that I like Transcend media cards the best because they are well balanced. They read and write quickly in card readers and in my camera. Use smaller size media cards in case you shoot on a media card you have already shot on or something happens to the card. Trust me, it is a lot easier to lose 2 GB worth of work than 16 GB! You can purchase media cards online through Amazon or go to your local Best Buy.

What's in My Camera Bag?

Here is a look at the items I keep in my camera bag. Use this as a starting point for putting together your own camera bag.

- Two SLR camera bodies (Canon EOS 5D Mark II)
- Two speed lights (external flashes)
- An assortment of about five lenses
- Battery pack
- Tons of rechargeable AA batteries
- Media cards (usually two to four gigabytes in case something crashes)
- Reflector
- Flash diffuser
- Tripod
- Ladder
- Battery chargers for cameras and AA batteries (both regular and rechargeable)
- Business cards
- Event cards
- Point-and-shoot camera (I use a Panasonic Lumix GFI; I bring it with me everywhere I go)
- Energy bars

- Water
- Lipstick
- Breath mints
- Cell phone
- Tissue
- Fanny pack (Even though it isn't stylish, it's perfect to carry around extra media cards and batteries, and it holds my battery pack, the couple's shot list, and anything I might need quickly at any time.)

Choosing Your Computer

In addition to having a great camera, you need to have a reliable computer as well as the latest software. It is important to have a dependable computer because it will be a big part of your business. You will use your computer to edit photos, post pictures to your clients, make and maintain your website, market to clients, make slide shows of your work, upload pictures, and more. Even if you have a computer at home already it is a good idea to have a separate work computer to put in your office or studio. Make sure you choose a computer that you like and that your company can grow with because it will be with you for a long time.

Choosing between a PC and a Mac can be hard. The main difference between the two is the operating system. A Mac computer runs on an OS X operating system while PCs usually run on Windows. The next big difference is hardware customization. In general, when you buy a Mac (with the exception of a few) you do not have a lot of options. You can change the hard drive and RAM, but not much else. With a PC almost everything is customizable and you can even build one from scratch.

Another difference is mouse capabilities. On a PC you have two mouse buttons but on a Mac you only have one. You can still right click but you have to hold down the "control" key to do so. In addition, a PC has a "Start" menu and a Mac does not. In order to find a program on a Mac you use a customizable dock that you can move to different parts of your background, or you can use its "Spotlight" feature.

Nowadays you can get the same programs for both types of computers, so when it comes down to it, choosing between a Mac and a PC is a matter of preference. I choose to have a Mac because it is what I'm used to. I've always had one. For me it makes sense because I already know how to navigate around. Most of my photographer friends are Mac people, too. I have a laptop and two desktops.

After choosing the type of computer you want, you need to choose between a laptop and a desktop computer. I have both because it is convenient. If I need to bring a computer on a job with me, or into the studio, I can easily grab my laptop. For editing photos I prefer the larger screen and the capability of a high-speed desktop.

After choosing either a Mac or PC and then a desktop or a laptop, you need to make sure your computer has certain features. As a wedding photographer you need a lot of memory and a large hard drive. You will be storing and manipulating a lot of pictures on your computer so it is important to have these two features. All of my files are backed up on several external drives. This is critical: I cannot stress enough the importance of backing up your image files.

Editing Software

After choosing your computer, you need to choose programs to help you with your new business, specifically for editing and managing your photographs. Adobe Photoshop is probably the most well-known program for this purpose, and the one that might sound familiar to you. I like to edit using Adobe Photoshop because it is what I've always used and I am familiar with it. It has everything that I need and it is fairly simple to use once you play around with it a little.

Another photography program is called Apple Aperture. It has features that are easy to use and that come in handy. As you import photos into the program, it backs them up to your external hard drive and saves them on your computer, which is extremely useful.

Adobe Photoshop Lightroom allows you to store your photos, edit them, and make slide shows with music, which is valuable when showing clients your work. A program called Studio Solution for Windows helps to integrate all aspects of your business. It allows you to edit photos, make slide shows, and also manage clients and scheduling—all in one program.

One thing to keep in mind when choosing a program is whether you will be shooting in RAW and jpeg formats. If you choose to shoot in RAW format you will need a program that can convert RAW images into jpegs. Some programs come with a RAW converter feature, but if they don't you will need a separate program. I shoot in RAW because it allows me more room to edit a photograph. Since I use Photoshop to edit my pictures, I can easily convert all my files to jpegs once I'm done.

If you choose a photo-editing program that does not convert RAW photographs into a jpeg format, you will need to purchase a separate program to do this easily.

One program I like is called Contenta. I like it because you can use it on a PC or a Mac, it is fast, and it is also priced modestly. You can visit Contenta Raw Converter (www.contenta-rawconverter.com) if you would like to learn more or purchase the program. Another program I like is called RAW PhotoDesk, a program for Windows. It is inexpensive and supports most files.

Getting Experience Using Your Editing Software

After choosing programs to help you with your business, it is imperative to master them. You need to know the program inside and out in order to do your job well. My advice is to play around as much as you can with editing photographs so that it becomes like second nature. Some things to keep in mind when editing are cropping images, color correction, and retouching. These are the three main components you need to know about to edit an image. We'll get to more about these three in chapter 11.

It is important to take digital workflow classes either online or in a town or city near you. Photography associations have chapters in each state that host these types of workshops. They go over anything from software to workflow to the whole editing and retouching process. I took an intensive five-day Adobe workshop in Oregon when I started my own business, which helped me develop a system and master digital workflow. It is critical to take these workshops until you feel very comfortable using your new software because it is key to running your business.

You need to master the use of your cameras but equally important is mastering the workflow on your computer.

If you are interested in taking a class to help develop your digital workflow, do a search online. Search for photography associations near you that offer workshops for the public to attend. Some of these associations might even offer online classes you can take in your own home. Professional Photographers of America (PPA) often has two- to three-day basic business workshops that can be really beneficial when you're first starting out. Classes are scheduled around the country, so chances are there is one near you.

If you can't travel or go away for two to three days, visit your town hall or parks and recreation center to see if they offer adult education programs. Another option is to go to a local community college or university that offers classes. A lot of times you don't need to be a registered student—you can enroll in just one class per semester. Before you sign up for anything, check out all of your options to see which one is the most beneficial to you.

Client Proofing Sites

Another thing to keep in mind when starting a business is researching client-proofing sites. It is important to have a client-proofing site because you won't always have enough time to meet with every couple to give them a slide show presentation. A proofing site also allows your bride and groom to view their wedding photos at their leisure and with privacy. With today's technology a client-proofing site offers a couple and all the guests at the wedding the convenience of seeing the wedding photographs quickly and in their own home. There are many different client-proofing sites out there, each offering its own unique features. Like choosing a computer, it comes down to personal preference, and there is no right or wrong answer. I use a site called Pictage because it offers everything I need. Pictage is also my print lab. Two of my friends referred it to me, and I have used it ever since. More about Pictage in chapter 11.

The best way to choose a client-proofing site is to first think about what services you are looking for in a site. Choose a site based on how well it will work for you, and not by price or popularity. I selected Pictage not only because of its features but because it is convenient to use the site as my photo lab as well. At events I hand out event cards (more on these in chapter 8) that have the URL of the site on them, so guests can log on and look at pictures after the wedding. I can't tell you how many

guests end up buying prints! I now bring event cards at every single event I shoot because my print sales have skyrocketed since I started handing them out.

Another great client-proofing website is FolioLink, which has a specific section just for weddings. Like Pictage, you can sell prints on this site as well as totally customize each client folder to be personal to them. If you want to find out more, you can visit the site at www.foliolink.com/wedding.asp. Collages.net (www.collages .net) is another great site, also easy to use and very convenient. Like Pictage and FolioLink, clients and their guests can purchase prints through the site.

Like I mentioned above, since I switched to Pictage and started handing out event cards, my print sales have gone through the roof. I would consider choosing a site that has a photo lab where clients/guests can order prints right from the site and have them delivered directly to them. This is a great service and a way to up your revenue.

External Hard Drives and Backing Up Your Files

The most important thing to remember after doing a shoot and uploading the pictures to your computer is . . . backing up the files! After you have uploaded pictures to your computer you need to back them up to an external hard drive. Having external hard drives is absolutely necessary for any photographer because you cannot back up your files often enough.

Backing up at different stages is the best way to ensure that you won't lose your work. It is also critical to back up each wedding you do to a DVD. Keeping these in a fireproof safe is a good idea. I cannot stress enough how important backing up your files is for a wedding photographer. It might seem redundant but trust me, it's better to be safe than sorry.

There are two types of external hard drives to consider: a "pocket" and a "desktop" external hard drive. A pocket hard drive is portable and lightweight. It uses a USB connection to function. On the other hand, a desktop hard drive is usually larger and needs its own power supply.

There are two main components of a hard drive to look for when choosing one: high storage capacity and high-speed connectivity. It is best to go with the biggest storage capacity available because of large image sizes and the number of photos you will be taking. I recommend at least one terabyte of space and at least four connectivity ports. The ioSafe Solo is a great external hard drive. It is waterproof and fireproof. It is available with 500 GB, 1 TB, or 1.5 TB of space. You can find out more

at www.iosafe.com. Another good hard drive is the GoFlex and you can choose up to 3 TB of space. This device also features automatic and continuous backup, which is a good idea. You can learn more about it at www.seagate.com.

I also use Time Machine on my Mac every night to back up my files. Time Machine allows you to automatically back up all of your files on an external hard drive that you leave connected to your computer at all times. If you accidentally delete a file you meant to save, you can go back and recover it. It is a useful program to have.

Another backup program offered online is called Carbonite. It is available for both PCs and Macs and costs one flat rate a year, which is nice because some backup programs charge you based on how much you back up. Carbonite automatically backs up your files securely online, and you can access your files anywhere at any-time. It is one less thing you have to think about. You can go on www.carbonite.com for a free trial. Carbonite has tutorials and offers support with a lot of categories in case you have any questions.

Ideal Computer Needs Checklist

- ❏ Apple Mac Pro (main computer)
- ❏ Two external hard drives
- ❏ One portable hard drive
- ❏ On-site backup storage
- ❏ Secure and encrypted off-site backup system
- ❏ Secure broadband Internet service
- ❏ Apple MacBook Pro (laptop, optional)
- ❏ Photo printer
- ❏ Photo editing program
- ❏ RAW converter program
- ❏ Automatic online backup program
- ❏ Client proofing site

For some jobs that may want a slideshow at an event like a golf tournament, it is good to have a "pocket" external hard drive like the HP 500BG Pocket Media External Hard Drive, which is about the size of a wallet. It is a good idea to have a lightweight and easily portable hard drive for instances when you need to bring one on a job. This one is the perfect size to fit anywhere, even your pocket. Another option would be the DataStor SATA Ultra Series 5400RPM High Performance Drive. This one comes in a variety of different storage capacity options and is compact for easy portability. This drive does not even require an additional power source because it gets all the power it needs from the USB cable, which makes it even more convenient.

Finding What Works for You

Choosing a computer and the programs to go along with it is not always simple. It is good to shop around and look for something that best fits your needs as a wedding photographer. A program that works for me might not necessarily work for you. Look at all of your options and try to narrow it down to two. After that, it is easy to look at the specifications of each product and compare them in order to find out which will fit your needs the best.

03 | Setting Up Your Home Office and Studio Space

Having a personalized office space and/or studio is really beneficial to a wedding photographer. Having a home office is absolutely necessary, while on the other hand a studio is something you can live without. An office is crucial because you will be running your business from it, and it can also double as a place to meet your clients. If you have a single room in your house that you can either turn into an office or a studio, start with the home office. It's not critical to have a studio because you can always rent a place if you book an indoor photo shoot.

Keep your office and studio together if you can, but if you can't, you can separate them. You need an office, regardless, but the room where you hold client meetings is the most important. If you only have room in your house for one or the other, remember this: You can always go meet people at a coffee shop. They don't always have to come to your house, but it is more convenient.

Rooms that Make a Good Home Office and/or Studio Space

Something to keep in mind when choosing a room for an office or studio: It doesn't have to be permanent! In my current living space, I started out with my office in a formal living room and had my studio in my detached garage. Then I moved my office from my house into the garage. Recently, I separated them again and moved my office into my dining room. Ideally, I would like to keep them together but I would need to take out a small loan to renovate and make my garage two stories. For right now I can live with them being separate and make it work.

Dining Room

Dining rooms are usually never used, which is why they can easily be turned into an office space. I had my first office in my dining room and it was very

convenient. If you have the room to put in a conference table, it can also be the perfect place to meet with clients. Dining rooms are also great because they are usually near living rooms, and a TV can be used during client meetings to show presentations, rather than a computer screen. Having a closed-off dining room (with doors) is ideal for when you need to edit or concentrate. Also, having doors provides privacy when you have clients over and gives off an air of professionalism. It shows that you have a private space for your business. This proves that you take your business seriously and you have put the time and effort in to making it legitimate. If you decide to turn your dining room into a space for your office or for meetings, it would be a wise investment to close off the room and add doors.

Attic

If your attic is finished and easily accessible, this space can be turned into a home office. Again, this space is typically hardly used so it can easily transform into an office or studio space. Having an attic as a home office is very beneficial because it is closed off from the rest of the house and can be more private.

My first studio was in my attic—and it was the first space that I turned into an office and studio so I had a lot of fun with it. It had high ceilings and I painted everything white. I had retro 1950s-era stainless steel desks and chairs, but learned that you need comfortable furniture over stylish furniture. I had a carpenter come in to put up paper rolls that I could pull down and use for portraits. I had amazing light in the attic, so I could do headshots in this space. I had a round table and two chairs where I would sit and talk to clients, and I always kept fresh flowers around. There was a little landing before you went up the stairs to the door and I hung artwork and placed a couch there so clients could sit if they had to wait. I kept albums up there as well, but almost everything—right from the beginning—was on my laptop. I used iPhoto to make slide shows that I would show my clients. It wasn't ideal because they had to walk completely through my house to reach the office, but it was a really happy and creative space, and I loved it.

Garage/Detached Garage

A detached garage is the perfect place to have an office or studio. A big reason why I bought my current house was because it had a detached garage and this is where my studio is now. A garage is an ideal place for an office or studio because it is slightly away from the rest of your house and usually has its own entrance. What I

love about having my studio in my detached garage is that clients don't have to walk through my house to get there.

How to Set Up Your Home Office and/or Studio

Even though it is an office, it is still important to keep in mind that the space is a reflection of your taste. Your office should reflect your taste because it can be an inspiration to you as you're working but also because it reflects you to your clients that will be viewing your office and getting a first impression from you. This room should be in the style that you want to give off to your customers about what kind of photographer you are and what style you like as a professional. Another thing to keep in mind is to organize your space so that your office is functional. If you have a large enough space to accommodate both an office and studio, make sure to keep them separate and not jumbled. If there is better light on one side of the room, make that your studio, and if there is good wall space on the other, make that into your office so you can hang photographs. A good way to make a large space seem separated is with a tall, long divider screen.

The most important thing to remember when setting up your office is that you're going to be in there a lot. It is very important to have a great sound system. For me . . . if I have to edit, then I have to listen to music. It's also beneficial to have inspirational things around, whether it is your favorite quotes in frames or your own photography. Editing can be a long process and having something that inspires you near your desk can be a big help. Make sure you

have a comfortable chair and that your desk is the right height and comfortable for you to sit at for long periods of time.

The most important thing to remember when setting up your studio is that it has enough light, but not too much light. I prefer natural light, so when I decided to make my detached garage my studio I had bigger windows put in so light could pour in. I painted my studio all white because I like the way it looks—very clean.

Checklists for Your Home Office and Studio

Following are lists of what you may need for both a home office and a studio. You can use these lists as a reference when setting up your own home-based office or studio to make sure you have everything you need. Here is what you will find in my home office and studio.

Home Office:

- Laptop
- Desktop (flat screen/large monitor)
- A phone with two business lines
- A phone message book (I make sure to write every single message down and keep the book at least a year in case I need to refer to it)
- Headsets for the phone (makes multitasking so much easier)
- Fax machine (I have a four-in-one fax/printer/scanner/copier)
- Postage meter (I send a lot of contracts, DVDs of pictures, and thank-you cards, so having this is a lifesaver)
- Postage meter tape
- Two calculators
- Stamps that say original or copy (I use these when I send contracts to couples so they know which to send back to me and which is theirs)
- Rubber bands
- Paper clips
- Tape
- Envelopes to mail prints out (I have every size imaginable because you never know what you might need)
- Letterhead and envelopes (it looks a lot more professional than plain card stock)

- A filing cabinet to keep track of all of my clients (I keep these records forever. My office has a filing cabinet for the fiscal year. The records from previous years are in my basement.)
- Hanging files
- File folders
- Customized sticky notes with my logo
- Business cards (always, always have extra on hand)
- Thank-you cards with my logo (to send after weddings)
- Card stock (to send anniversary cards to couples)
- Address labels
- Return address labels
- Pens with my logo
- Highlighters
- Magnets with my logo
- Sticky notes that say "sign here" for contracts
- Presentation folders with my logo
- Wedding brochures/envelopes
- Four different printers (black and-white laser, color laser, 4x6 laser, the four-in-one inkjet)
- Extra ink for printers
- A card reader for media cards
- External hard drives
- A paper cutter
- Clipboards
- Legal pad for notes
- Spiral journals to write notes "on-the-go" (I take one with me when I go out to meet clients)
- A stapler
- Two dry-erase boards (one that says edit/post, albums, per/edit, vendors to keep track of my jobs; the second board I use for my personal photography)
- Dry-erase markers
- Photo paper (different sizes)
- Printable blank DVDs and CDs
- Slim cases for mailing DVDs or CDs

Home Office Mailing Systems

When you are in the process of setting up your home office, make sure you do three things:

First, set up an account with FedEx online. This is a complete lifesaver and will save you a lot of time. You will be mailing things out all the time and it doesn't make sense to bring it all to a mailbox or to the post office. With a FedEx account, you can print out mailing labels from home, track packages you've sent, and schedule a pickup—a FedEx truck will come right to your door and collect anything you need to send out, whether it is prints or contracts. Having an online account with FedEx makes shipping ten times easier.

Another thing to set up is a site that you can use for e-mail blasts. Two really good sites are www.constantcontact.com and www.icontact.com. Both of these sites are known for being easy to use and they are affordable. I would recommend setting up an account with a site from the get-go so you can begin sending out e-mail blasts early on.

The last thing to set up is an account with an office supplier that will deliver to your house. Sites like www.wbmason.com and www.quill.com are very easy to navigate, make shopping for office supplies very convenient, and they both have very quick delivery. You'll often find you don't have time to run out and get office supplies, so ordering things you go through quickly in bulk will save you time and money in the long run.

Studio:

- Business cards
- Framed artwork
- Two to three camera bodies
- Two external flashes
- Three to five camera lenses
- Rechargeable batteries with chargers
- Reflectors in different sizes, such as rounds and rectangles, with a diffuser

- Several paper backdrops (nine feet and five feet. I always have super white, slate gray, and a bright color)
- Several cloth backdrops (I have black, white, gray, and cream colors on hand)
- Several different shapes of soft light boxes (rectangle and a large round)
- A set of strobe lights (I use Photogenic, with two light heads that I typically use umbrellas with or the soft boxes)
- A set of natural lights (not strobes; used as fill lighting)
- Four to six light stands
- A wind machine
- Six to twelve C-clamps
- Several sizes of ladders
- Twenty media cards
- A client contact form for wedding and other portrait shoots
- Several sand bags (used these to hold down paper or cloth backdrops and to hold up reflectors.)
- Duct tape
- A tool box that contains a hammer, screwdrivers, cleaning kits for my cameras
- Tripod
- White cards for reflection (usually I use 36 x 24-inch foam core board)
- A makeup table with mirrors and stool
- A clothing rack and a changing area
- A great stereo with an assortment of music
- Water, coffee, and/or tea

Setting up your home office and/or studio can be a really fun and exciting experience. It can also help get the ball moving and motivate you to start making vendor relationships or begin to lay out how you want your website to look. This is it—you've finally decided that becoming a wedding photographer is right for you and now you are pursuing a career. It can be a nerve-racking time, but try to think of all the positive things that will come from being a photographer. Having a really cool office and studio that you never want to leave is a start!

04 Creating Your Company

Creating your company can be difficult, confusing, and scary—so don't be afraid to ask for help. Finding a lawyer and an accountant is very important for this aspect of your business development. There are many twists and turns and you will have many questions, so find professional help to ensure that you do everything properly. Down the line you will need help from a graphic designer and an SEO expert, but it's a good idea to start with the "boring" stuff and trudge your way through it.

Get your friends together to get their opinions on the business names you have come up with, and see if they have any ideas. Friends oftentimes are the best help when you need constructive criticism and when you are making an important decision, like deciding on the name of your company. You can also ask if they know any good lawyers or accountants. It is always best to get referrals from friends rather than just do a search on the Internet. Creating your company can be a big task, but with the help of professionals and loved ones, it can be a fun learning experience.

Deciding on a Business Name

Choosing a business name is one of the most important early decisions you will make. Picking a name that people will remember and that is catchy can help you find more clients and therefore will produce more work for you. On the other hand, choosing a name that is hard to pronounce and easily forgettable will do just that—make potential clients forget your name. There are many different factors you need to consider when choosing a name.

For one, it should be easy to spell and to say out loud. Another thing to keep in mind is how the name will work in other marketing activities, such as on business cards and as a domain name. I think using your full name is best

for branding yourself. If your last name is difficult to pronounce, you might consider using just your first name. Using your name as a business name can come in handy. Not only will people remember you, but if you ever need to relocate, your business name can easily move with you. However, if you have a first and last name that you think is too common or too hard to say, you should think about a photography business name that suits you. For example, if your first name is something very common like "Brittany" and your last name is also something common like "Smith," it might benefit your business to come up with a name that reflects your creative side rather than focusing on your name, which could get lost in a sea of other names because of how common it is. Or if you have a unique middle name or nickname, consider adding that instead of a last name to spice up your business name. Like if your full name was "Brittany Cortright Smith" consider using "Cortright Photography" or "Brittany Cortright Photography" instead of just "Brittany Smith Photography." On the other hand, if you grew up with a first or last name that everyone was always mispronouncing, consider eliminating that from your business name to avoid confusion.

It is also important to consider a domain name when thinking about a business name. There are tons of photography websites online nowadays, so it is important to choose a business name that can also be used as a domain name that is not yet taken. Choose a few that you like because chances are, one of them is already taken. There are sites like Register.com or Godaddy.com that can help you find out if a

The Importance of Having the Right Business Name

There are many different reasons to put a lot of thought into your business name. As a business owner it is crucial to think of the image that you want to portray, and your business name should reflect that. It will be the first impression your business makes on a potential client, so it is imperative that it is a good one. Your business name should include what type of business you are. This will help potential clients remember your business more easily and will also make it easier for clients to search for your name in a phone book or on the web. My parents did a great job naming me. I'm happy with my name and decided when I started my business to use my name: Kristen Jensen Photography. I then added a tag line: Capturing Life with Style. People remember it.

domain name is already being used. I recommend buying as many as you can. You can then have all of them directed to your main site.

Having a Business Plan

When you first start out it is important to have an idea of what your budget is and how much capital you have. In an ideal world, you would have enough savings to start your business without taking out a loan. However, many times this is not the case. Many new businesses start by taking out a small loan. If you have don't have that option, it is important to keep working a side job in order to save enough to start your business.

When you come up with a budget and you're trying to decide how much money you need to start your wedding photography business, double it. For me, I dipped into a savings account I started when I was modeling. I had about $15,000 to start my business and went over that amount.

Before you decide whether or not to apply for a loan, you need to assess what capital you have personally to put into your business and you need an estimate of

Estimated Start-Up Costs

Here is a list of items you will most likely need to start (and the rest can come later):

Computer	$3,000
Computer Equipment	$1,000
Software	$4,000
Camera Equipment	$6,000
Advertising Expenses	$5,000
Photo Printer	$1,000
Total Costs	**$20,000**

This is an estimate and can vary depending on if you already have some of the things you need. This would be a good start and you can always save up for extra things or upgrades later on in your career. To start, it is only necessary to get the bare essentials. Add more once your business takes off and you have more capital.

start-up costs. It is a good idea to make a list of everything you are going to need and calculate how much you think it will all cost.

It is always a good idea to overestimate by a couple of thousand dollars in case you have any unforeseen expenses or setbacks. Your car could break down, or you might want to add something to the list—like a camera bag—that you didn't calculate from the get-go. Unfortunately, I would be lying if I said I didn't go over my original planned budget. I spent more than I thought on computer equipment, and things add up very quickly. It would have helped if I had had bigger leeway when I calculated my expenses, but you live and learn. Now I can pass that piece of advice on to you and hopefully you can learn from my mistake.

Taking Out a Small Business Loan

If you decide to take out a small loan you are going to need to be prepared. By being organized and having certain documents handy, you will greatly increase your chances of securing a loan. One of the most important things you will need is a business plan. A business plan will help to show why you need the money and where the money will be going.

Follow this general business plan outline and personalize it to define your new company:

- Executive Summary
- Company Description
- Your Customers
- The Competition
- Marketing and Sales Plan
- How You Do Business
- Your Team
- Future Goals and Exit Plan
- Financial Statements

Another document that you will need to have drawn up is a cash flow projection sheet. The lender will want to assess the risk involved in potentially loaning you money. Having a well-prepared document showing how you will make the money to pay back the loan will increase your chances of getting approved. See the sample template of a cash flow projection sheet that you can create in any Microsoft Excel program on pages 36 and 37.

Small Business Cash Flow Projection								
<Company Name>								
Starting date								
Cash balance alert minimum								
	Beginning	Jan-00	Feb-00	Mar-00	Apr-00	May-00	Jun-00	Total
Cash on hand (beginning of month)								
CASH RECEIPTS								
Cash sales								
Returns and allowances								
Collections on accounts receivable								
Interest/other income								
Loan proceeds								
Owner contributions								
TOTAL CASH RECEIPTS								
Total cash available								
CASH PAID OUT								
Advertising								
Commissions and fees								
Contract labor								
Employee benefit programs								
Insurance (other than health)								
Interest expense								
Materials and supplies (in COGS or cost of goods sold)								
Meals and entertainment								
Mortgage interest								
Office expense								

Other interest expense								
Pension and profit-sharing plan								
Purchases for resale								
Rent or lease								
Rent or lease: vehicles, equipment								
Repairs and maintenance								
Supplies (not in COGS)								
Taxes and licenses								
Travel								
Utilities								
Wages (less emp. credits)								
Other expenses								
Other expenses								
Other expenses								
Miscellaneous								
SUBTOTAL								
Loan principal payment								
Capital purchases								
Other start-up costs								
To reserve and/or escrow								
Owners' withdrawal								
TOTAL CASH PAID OUT								
Cash on hand (end of month)								
OTHER OPERATING DATA								
Sales volume (dollars)								
Accounts receivable balance								
Bad debt balance								
Inventory on hand								
Accounts payable balance								
Depreciation								

In addition to these two documents, have a copy of your personal financial records of assets and debt. This will give the lender a better idea of what kind of candidate you are, and whether you would be able to pay back the loan on time. When meeting with the bank or lender, be ready to answer these types of questions:

- Why do you need the money and where will it be spent?
- How much personal money are you putting into the business?
- What collateral do you have?

You should also be prepared to talk about your business, how much experience you have, and what your future plans are for the business. It is best to be overprepared when going to get a business loan. Not only does it show that you are serious, but also that you know what you're talking about.

Legal Aspects of Creating Your Wedding Photography Business

This part of building your business may be confusing or boring. It was for me, so I hired a lawyer. One of the first things that I had to decide was what type of business I was going to have. With my lawyer, we decided it was best to be a Limited Liability Corporation (LLC). My full business name is: Kristen Jensen Lifestyles, LLC.

There are many different legal aspects to running a business out of your home, so even if you are familiar with your state's laws, a lawyer can help you start your home-based business the right way. I also had to get a permit from the local town

Small Business Organizations

Organizations like Service Corps Of Retired Executives (SCORE) and the Small Business Administration (SBA) can help you start your business. SCORE has a very informative website, where you can get advice on pretty much every topic pertaining to opening up your own business. The group offers free online workshops, and webinars you can listen to at your convenience. SCORE is a great way to find answers to specific questions you may have, and offers great advice to those starting out. The website, www.score.org, is a must-see for new business owners. Another great website to check is www.sba.gov. This site offers information about getting a loan and can help you prepare your finances.

hall to operate a business from my home. Check with your city or town, as well as your state.

Corporation or LLC

The first thing to consider is whether you want to be a corporation or an LLC. Incorporating can protect you and your business from liability issues. The type of home-based business determines whether a corporation or an LLC would be a better fit. For a home-based wedding photography business, an LLC is probably better. A mix between a corporation and a partnership, an LLC protects its members from personal liability for the debts and the obligations of the company. An LLC is normally taxed like a partnership, which gives its members a great deal of flexibility when allocating its profit and loss.

Registering Your Business

I would suggest you do what I did and hire a lawyer for this aspect of creating a business and registering your name. As an expert in this field, a lawyer can help guide you through the process and ensure that it is done correctly. This is also an example of an unforeseen expense you will incur when opening your business, as referenced in the Having a Business Plan section.

You might think you should go ahead without one, but hiring a lawyer can be extremely helpful and takes a load of stress off your plate. Understanding state documents and requirements is not always fun or easy. You can visit www.usa.gov to find out more about obtaining documents to start your business.

There are five steps to registering your business:

1. Determine the legal structure of your business. Have you decided to be a corporation, an LLC, a sole proprietorship, partnership, etc.?
2. Register your business name. Will your name be an assumed name, doing business as, or a fictitious name?
3. Obtain your federal tax ID. In order to get this you need to contact the U.S. Internal Revenue Service. You might also need to get an Employer Identification Number (EIN), which you can apply for online at www.irs.gov/businesses/small/article/0,,id=98350,00.html.
4. Register with your state revenue agency in order to obtain tax IDs and permits. Since you will most likely be collecting sales tax, you will also need a vendor's

license or a sales tax permit from your state and local governments. All of these forms can be found online, or you can go to your town hall to get them.

5. Obtain licenses and permits to run a business out of your home, which can be found online for your specific state.

Obtaining a Business License

The next thing to do as far as the legal aspects of your home business are concerned is get a business license. Because some states do not require this, it is important to research your state's business laws so you get the proper certification or license. Since you will be running the business out of your home, you may need to be zoned for commercial use. In order to get the proper zoning you'll need to go to your local courthouse or city hall to get the paperwork started. At the same time you can get the DBA (doing business as) paperwork, which will allow you to get a business checking account and a business phone line.

You will also need to fill out the paperwork for your business license. You may be asked things like what your business is worth. Be as truthful as you can when filling this paperwork out. There is a fee to obtain your business license, which can vary from state to state. It is either a flat rate or it can depend on your business's potential revenue. This is another example of a hidden expense that you might not have factored into your business plan.

Permits

Since you are running a home-based business you will also need to obtain permits in accordance with a business license to operate out of your house. Research your state website to see which permits you are required to have. Failure to obtain proper permits can mean that your business could get shut down or you could receive a fine. Permits are used to regulate safety and maintain the structure of the community, and are mandatory.

Obtaining a permit is similar to getting a business license. You will need to:

- Research the permits you need through the appropriate agency.
- Make sure your business complies with the ordinances in your area.
- Obtain the proper application forms and/or set up the proper applications procedures.
- File the necessary paperwork to obtain the relevant permit(s), and pay any filing fees.

Two permits that home-based photographers will most likely need are a zoning permit and a home occupation permit. A zoning permit can help you legally build on your land, which means that you can add parking for clients if you would like. You will need a home occupation permit if your state restricts home-based businesses.

Insurance Needs

In addition, you need to obtain insurance. Because you are now self-employed, you'll need to find your own health, life, and dental insurance. It is best to shop around for the best insurance to fit your lifestyle. You also might look into business property insurance, which will insure that you will not be held responsible in the event of an accident. Many wedding and event venues that I shoot at require a certificate of insurance. Typically, the venue will require that you at least have $1 million of liability insurance.

Insurance Tips

Make sure you are completely insured. Typically this means purchasing commercial general liability insurance (including contractual and products liability) with coverage of $2 million. The PPA (Professional Photographers of America) offers liability insurance and equipment/camera insurance.

You can never be too insured. I always think it is better to be safe than sorry. A home-based business needs a lot of insurance to protect itself if something happens. There are many types of insurance for home-based businesses that will help you cover every possible circumstance.

First off, since it is your livelihood, you might consider getting business property insurance. You will need to determine the replacement costs of items like your computer, computer equipment, camera, camera equipment, office supplies, furniture, and studio equipment to see how much business property insurance to get. Cover what you need and then some, even if that means extra monthly expenses. Make sure you are prepared for any type of situation (e.g., a flood, fire, or any other natural disaster).

Types of Insurance

I carry several insurance policies. I have homeowners insurance, automobile insurance, and business insurance. My business insurance is under my LLC name, Kristen Jensen Lifestyles. The total cost annually for my insurance package is around $1,325.

My business owner's policy (BOP) includes liability and workers' compensation. With regard to liability, I have property and bodily injury coverage at $1 million per occurrence, and that is capped at $2 million. I am often asked by the venues where I shoot to provide a certificate of insurance. When requested, I e-mail my insurance agent and she issues a certificate that same day. Most clients will ask for a minimum of $1 million in liability.

Included in my BOP is insurance for my camera equipment and all my computers, at $80,000. This is in the event of a fire or theft. I always use an alarm on my studio and home, but theft could happen at an event and having this replacement insurance is important.

Also included in my BOP is workers' comp. I have coverage of $100,000 per employee, with a $500,000 cap. This is very important in the event an assistant or second shooter gets injured on one of your photo shoots.

A local insurance agent can guide your through the coverages and help you determine what is right for your business.

You should also consider getting a commercial/business automobile policy if you use your personal car for business needs. Check with your automobile insurance company to verify, but most of the time, if you are in an accident using your car for business purposes, it will not be covered by your normal car insurance. Since you will be traveling often and to various destinations that might be far from your home, protect yourself by getting a business automobile policy.

Since you are now self-employed, you will need to supply your own health insurance. There are many options to choose from and you need to do research to find which is best for you and your family. If you are just starting out and are without insurance, you might be eligible for Consolidated Omnibus Budget Reconciliation Act (COBRA) which is temporary interim coverage. You can find out more

information and see if you are eligible at www.dol.gov/dol/topic/health-plans/cobra.htm. Since this line of work is so physical, it may be wise to look into disability insurance, which would provide you with a source of income should you fall ill and not be able to work for a span of time. This insurance is not necessary but can give you extra peace of mind.

You will also need comprehensive general liability insurance, since you will have clients in your home. This type of insurance protects you should any of your clients get hurt while on your property. This is a must if you have a studio and hold frequent photo shoots, and if you will have clients over your house for meetings, to pick up prints, or to sign contacts.

The last type of insurance that I would recommend for a home-based business is life insurance. Life insurance is protection for your family, ensuring that your family has money if you should pass away. When you are applying for a business loan, some lenders require that you have life insurance because it guarantees that the loan they are giving you will be paid back in the event of your death. This type of insurance is not necessary but is very important, especially if you have a family and because you are a business owner. If you should die an untimely death, you don't want all of your business's debt to be left upon your spouse or children.

Taxes and Accounting

The biggest thing that might change legally for you once you start your photography business is your taxes. Owning a business means that you have to file taxes differently than you used to. To do this, I suggest enlisting the help of a professional. Tax laws are constantly changing and keeping up with them can be exhausting. Having a professional help you with your taxes will eliminate the amount of research you need to do on your own concerning your new business and its taxes. Having professional help will also ensure that you are paying

Expert Advice from a Bookkeeper

"Having Kristen separate her spending from all her business expenses has really helped us when it comes time to pay her quarterly taxes."

—Mona Klepp, bookkeeper for Kristen Jensen Lifestyles, LLC

enough in taxes. Tax professionals also can answer any specific questions that you might have.

I pay my federal and state income taxes quarterly and I have a bookkeeper that prepares the payments for me. I live in Connecticut, where the sales tax is 6 percent. I am required to charge sales tax for all my services.

Keeping Track of Your Expenses

It is so important to keep strict track of your business finances.

Use a program like Quickbooks to organize your bill paying and invoicing. Keep both a personal checking account as well a business checking account. All revenue should be deposited into the business checking account. When you are ready to deposit money, make a copy of the deposit slip and checks for your files. Use these documents when you enter deposits into Quickbooks. This will help you to accurately maintain your own records.

Designate a filing cabinet in your home office that is specifically for business expenses. Create file folders for your expenses and then file all receipts weekly to stay organized. Besides the copies of deposit slips and checks, most of your invoicing will be completed online and therefore is paperless. I am now making all of my bill payments online because it is very convenient. Very rarely do I actually write a check for business.

Another way to keep organized is to have separate credit cards for business and personal use. This cuts down on any confusion in regard to what is a business expense and what is personal.

For the independent contractors that work for me, I require an invoice with the client's last name and the date of the wedding or event. Typically, I pay a check online within two weeks of receiving the invoice.

Typical Monthly Business Expenses

Here is an example of my typical monthly business expenses:

- Cell and land-line phones (including my toll-free 800 number)
- Automobile expenses, including gas, tolls, parking, etc.
- One-half of light and power utility bills for my home
- One-half of cleaning and janitorial expenses for my home
- One-half of landscaping, driveway, and yard expenses for my home

- Lab and printing costs, including albums and proof books
- Custom framing costs
- Marketing materials (brochures, business cards, letterhead, presentation folders, etc.)
- Postage and FedEx costs
- Office expenses (e.g., pens, paper, padded envelopes, photo paper, CDs, DVDs, and ink for the printers)
- Photo equipment (paper backdrops, drop cloths, media cards, lights, reflectors, etc.)
- Any entertainment expenses (e.g., lunches or dinners with clients, client gifts)

Invoicing and Payment

I use Quickbooks for all of the accounting and bookkeeping aspects of my business because it is the most convenient way to manage the financial portion of my business, and it is fairly easy to use. Quickbooks allows me to track all my sales and expenses, and it is easy to create and manage all of my invoices. This program also allows me to manage all of my clients in one place. Quickbooks offers a program specifically made for Macs, and I can use my phone to access all of my information on the go.

Credit card processing can be expensive because of the fees, but I offer it for the convenience for my clients. However, the most common form of payment I receive is by check. If needed, I offer a payment plan for my clients. I accommodate my clients to make hiring me an easy decision. I offer to break down the payments by month, and they can send me monthly checks. It is important to be somewhat flexible in this sense because weddings are expensive, and it can be easier for a couple to have a payment plan. This is why it is important to have a well-structured and thorough wedding contract, to ensure payment even if it is by a payment plan. More on contracts later in this chapter.

Examples of Invoices

Make sure you create a new invoice number for each order so you don't get confused! I create all of my invoices in Quickbooks. You will find samples of a wedding invoice, a print invoice, an album invoice, and a balance due on a wedding contract invoice on the following pages.

KRISTEN JENSEN PHOTOGRAPHY

KRISTEN JENSEN PHOTOGRAPHY

123 Main Street
Any Town, CT USA
555-555-5555

Invoice

DATE	INVOICE #
02/01/2011	1355
TERMS	DUE DATE
Due on receipt	02/01/2011

BILL TO

Client Name
Client Address

PAID

BALANCE DUE	ENCLOSED
$0.00	

- - - - - - - - Please detach top portion and return with your payment. - - - - - - - -

Activity	Quantity	Rate	Amount
• WEDDING: KATIE & JOSH 8/28/11			
• Complete wedding package includes:		6,000.00	6,000.00T
-engagement portrait session			
-full coverage of entire event (pre-ceremony, ceremony, reception)			
-second photographer			
-online proofs			
-coffee table proof book			
-DVD of all images			
• Magazine Style Photo Album 10"x10"		2,000.00	2,000.00T
• Magazine Style 8" x 8" parent album w/identical layout	2	700.00	1,400.00T
• Subtotal: 9,400.00			
• Second deposit due by: 6/28/11		-2,350.00	-2,350.00T
• Third deposit due by: 7/28/11		-2,350.00	-2,350.00T
• State Sales Tax 6%	4700	6.00%	282.00

SUBTOTAL	$4,982.00
TAX	$0.00
TOTAL	$4,982.00
PAYMENT	$4,982.00
BALANCE DUE	$0.00

KRISTEN JENSEN PHOTOGRAPHY

123 Main Street
Any Town, CT USA
555–555–5555

Bill To
Client Name
Client Address

Invoice

Date	Invoice #
11/16/2011	1483

Description	Qty	Rate	Amount
5" x 7" print - image #426	3	15.00	45.00T
5" x 7" print - image #376	1	15.00	15.00T
5" x 7" print - image #290	1	15.00	15.00T
5" x 7" print - image #292	1	15.00	15.00T
5" x 7" print - image #50	1	15.00	15.00T
5" x 7" print - image #76	1	15.00	15.00T
4" x 6" print - image #369	1	10.00	10.00T
4" x 6" print - image #370	1	10.00	10.00T
4" x 6" print - image #371	1	10.00	10.00T
5" x 7" print - image #156	1	15.00	15.00T
5" x 7" print - image #699	1	15.00	15.00T
NOTE: all prints have an extra of same at no cost			
Frame: one frame for 3 - 4x6 pictures (to be billed)		0.00	0.00T

Thank you for your business.

Subtotal	$180.00
Sales Tax (6.0%)	$10.80
Total	$190.80

KRISTEN JENSEN PHOTOGRAPHY

123 Main Street
Any Town, CT USA
555–555–5555

Bill To
Client Name
Client Address

Invoice

Date	Invoice #
8/16/2011	1444

Description	Qty	Rate	Amount
Magazine Style Photo Album 10" x 10"		1,500.00	1,500.00T
TERMS: 50% deposit required to start design Balance due prior to shipment			

Thank you for your business.

Subtotal	$1,500.00
Sales Tax (6.0%)	$90.00
Total	$1,590.00

KRISTEN JENSEN PHOTOGRAPHY

123 Main Street
Any Town, CT USA
555–555–5555

Bill To
Client Name
Client Address

Invoice

Date	Invoice #
8/10/2011	1366

Description	Qty	Rate	Amount
WEDDING 9/25/11			
Third deposit due by: 8/25/11		1,250.00	1,250.00T
Thank you for your business.			

Subtotal		$1,250.00
Sales Tax (6.0%)		$75.00
Total		$1,325.00

Copyrighting Your Work

As a professional photographer, you must copyright your work. It is not true that a photo is automatically copyrighted to you just because you take the photograph and claim it as "yours." In order to copyright your work you need to properly register your photos and properly present your work. It is important to copyright your work in case you need to file a copyright infringement case against someone trying to copy or steal your work and pass it off as his or her own.

These are three easy ways to present your work the right way for copyright:

1. Include your professional photography name
2. Include the date of your photo's publication
3. Use the copyright symbol (©)

In order to register your photos, visit www.copyright.gov. It costs about $45 each time you want to submit a CD or DVD of photographs. You need to fill out the Works of Visual Art Form on the website and send the form and the pictures to the Library of Congress. Even though you can present your photos to make sure people know that they are copyrighted by you, it can't hurt to register your photos as well. It's up to you and isn't necessarily something you need to do from the start, but it is definitely something to keep on the back burner and think about.

Copyright is an important issue to clarify in your contract. In my contract it states:

> *5. Copyright and Reproductions. The Photographer shall own the copyright in all images created and shall have the exclusive rights to make reproductions. If the Client has the DVD negatives included in contract then Photographer will authorize a "copyright-transfer" to be issued to the Client. The Photographer shall be able to make reproductions for the Client or for the Photographer's portfolio, samples, self-promotions, entry in photographic contests or art exhibitions, editorial use, or for display within or on the outside of the Photographer's studio, website, advertising, and website blog. If the Photographer desires to make other uses, the Photographer shall not do so without first obtaining the written permission of the Client.*

It is crucial to have something in your contract that goes over copyright and reproductions because it protects you as a photographer and states that although you took a picture of someone else, the rights still belong to you, even if you

authorize a "copyright-transfer." It is also important to talk about using the photos on your website, for entering contests, or for any other use. Some clients may not want their pictures used but most of the time, they don't mind if you use them for your blog or your website. Usually they feel flattered. You should go over these items with your client prior to signing the contract in case there are any issues or if you need to allow for any special circumstances. Having a lawyer can come in handy in situations like these, because you may need legal advice.

Hiring Employees

Finding assistants and second shooters can be nerve-racking. How can you find someone you trust enough to work with you? It is always my rule to trust your gut when meeting someone. If you are unsure in any way about hiring them, then don't. Trust your instincts. It is always better to be safe than sorry.

It's important in the wedding photography business to find someone who is on the same page as you, meaning that they don't have to be told what to do, they are self-sufficient. It is stressful enough on a wedding day without having to worry about the second shooter you just hired, and whether or not they're going to do a good job.

If you live near a local college or university, put up flyers for "help needed" around campus. Make a flyer with what you're looking for and post it in the building where art classes are held or where there is a lot of student traffic, like a student center. Using local resources like a college or university is important because it is booming with students who need an internship or experience in the field.

Having an extra pair of hands on a wedding day is a great idea, especially if the person you have hired has already taken some photography classes and knows what he or she is doing. I live near Western Connecticut State University, which is fortunate because I have found great assistants there.

When I first started I reached out to other photographers when I was looking for help. I also joined the Professional Photographers of America (PPA) and Digital Wedding Forum (DWF) online. For more information on these organizations, check out the websites at www.ppa.com and www.digitalweddingforum.com. I posted what I was looking for on the forums on these sites, and they yielded great results. I have also used Craig's List online (www.craigslist.com) but I've found that referrals are the best way to find help.

When you hire someone (even if you interview them), you don't know how he or she is going to work out until you're in the thick of things, in the middle of the

wedding. Your second shooter and your crew of help speak volumes to your client about who you are and how professional you can be. That is why it's important to go with your instinct and only hire someone if you really believe they're going to work well with you and do a great job. It is good to have high expectations when hiring an assistant or second shooter because you want to make sure that they have the same views as you on certain things, like shooting style, customer service, equipment, and personal presentation.

Independent Contractor versus Employee

For small businesses, it is sometimes better to hire an "independent contractor" rather than an "employee." The main difference between an independent contractor and an employee is that as an independent contractor, you are your own boss. You don't work for a company, you work with a company. A company will hire you for freelance work but not on a full-time basis. What is great about hiring independent contractors is that they have their own equipment, are knowledgeable about the subject (need no training), and they are not your responsibility per se.

If you hire independent contractors, you do not need to do much more than sign a contract with them regarding the terms of agreement (e.g., the date that they will work for you, the payment amount, when payment is due, the hours of the job, and any details that might pertain to the day such as providing their own transportation).

If you hire employees, you will need to have them fill out two forms: an Employee Eligibility Verification (Form I-9), and a Federal Income Withholding Tax Form (W-4), which can be found on the IRS website, www.irs.gov. If you plan on hiring employees you must also have an Employer Identification Number, which I mentioned in the section on the legal aspects of starting your business, and you must set up records for withholding taxes. As an employer you have to fill out a W-2 form (Federal Wage and Tax Statement) annually. You also need to register with your state's New Hire Reporting Program. Check out www.sba.gov/content/new-hire-reporting-your-state for more information.

You also need to add another type of insurance if you decide to hire employees. You would need to obtain workers' compensation insurance, which ensures that workers who become ineligible to work still get paid. In addition, you have to file your taxes differently and keep track of all the paperwork you receive from each employee. You also may need to find a payroll provider. There are many options

online and sites like http://payroll.intuit.com/ make payroll easy and inexpensive. Hiring an accountant to take care of payroll and provide the right forms would be your best bet.

As you can see, hiring employees can be a lot of work for a home-based business, especially if your business is just taking off. My advice would be to stick with independent contractors until you feel secure and stable enough to take on the responsibility of having employees. I have always used independent contractors because of the ease and convenience. It is a better choice for me.

Developing a Pricing Structure

Figuring out your pricing structure can be tricky. The trick to determining the "right" amount to charge is to narrow down your target clientele. Is your client a ¼-carat diamond or a 3-carat diamond type? It is important to determine your perfect audience in order to figure out a pricing structure that will fit into their budgets, so you don't go too high or too low.

It is also helpful to look at your competition to see what their rates and fees are. This is important because if you have the same target clients, it is crucial to stay within a certain range of their rates so your potential clients won't rule you out for being too expensive or too cheap. If clients see that your pricing is way over another photographer in the area, they'll rule you out without even looking at your portfolio or website. If your pricing is way below a competitor's, a potential client might think the deal is too good to be true and think they might get scammed.

Another way to get good feedback on your pricing is through a trusted vendor or friend in the same business. I remember having coffee with a friend who is a top wedding planner when I first developed my pricing structure. I showed her my prices and she told me they were much too low. Having a second opinion that you trust is comforting and can help you be confident about your choices—or it can help you change your mind about your pricing, so it is more accurate.

Over the past few years I have developed a flat rate pricing structure. I also have "a la carte" items that can be added to the flat rate, to tailor to my client's personal needs and budgets. My flat-rate fee is substantially less on a Friday evening than on a Saturday, as well as for weddings between November through April. I have found that this is the best way to structure pricing because it allows me to have a straightforward price, but also allows my customers to add on to the package and customize it to their needs.

Another thing to consider when coming up with your own pricing structure is exactly what services you will offer and what you will not. For example, I offer proof books because I can use my client-proofing site Pictage to print and design them. You may decide you want to offer something like this and need to come up with a fair price. The best way to compare prices is, again, an online search. For a photographer starting out, you may want to start at the lower price spectrum and as you gain more experience, up your prices.

Also keep in mind whether you will include the price of a second shooter in the flat rate or if the second shooter will cost extra. I have included a second

My Wedding Package Prices

(I throw in an engagement portrait session to close the deal and get the contract.)

- Up to ten hours of coverage of the bride and groom getting ready, the ceremony, portraits, and the reception
- Online proofing
- A coffee-table proof book
- A DVD of high-resolution images
- A second photographer

$4500

Upgrades

A magazine album—twenty pages/forty sides with up to one-hundred images; bound in the clients' choice of leather or brushed metal

12 x 12 inch	$2000
10 x 10 inch	$1500
8 x 8 inch	$1200
5 x 5 inch	$750
DVD slide show	$500
Travel (outside a 60-mile radius of my studio)	$100/hr
Additional hourly rate	$250.00

Prints in any size and finish

Size	First copy	Additional of same	Prints on canvas
4 x 6 in.	$10.00	$5.00	N/A
5 x 7 in.	$15.00	$7.50	N/A
8 x 10 in.	$25.00	$12.50	$75.00
11 x 14 in.	$50.00	$25.00	$125.00
20 x 24 in. poster	$75.00	$37.50	$175.00

Retouching	$75 per image

shooter in my flat rate, but it is up to you whether or not to do the same. Some people might not want a second shooter if there aren't going to be significant numbers of guests, or you simply don't want one. Make sure you go over the use of a second shooter with the couple, even if it is included in your package and in your contract.

What Type of Coverage to Offer

When deciding what type of coverage to include in your wedding package, remember that it is an all day affair and that you will be there from start to finish. Out of all the vendors that are hired for a wedding, you should be the first and the last to leave. Capture every single moment of the wedding that you can—that is your job. When you are coming up with your pricing structure, specify an amount of time that is average for a wedding. For example, I say up to ten hours of coverage, and anything after that will cost extra.

Online Proofing

In your contract (for more on contracts, see page 59), you may include a section that goes over the client-proofing website and any details that pertain to it, such as how long the photos will be available, what photos will be uploaded to the site, if guests can access the pictures, etc. It is important to have a strict policy outlined in your contract based on your online proofing site's terms. You don't want a couple to approach you after five years asking why they can't view their wedding pictures online any longer. The best way to avoid any sticky situations is to be thorough and go over every guideline you can think of to avoid this.

Proof Books and DVDs of Wedding Images

Treat proof books and DVDs along the lines of the client-proofing website. You need to be very specific with your clients about exactly what will be on the DVD that you will send them in the mail. Will it contain every single image shot at the wedding or just edited photos, and how many? I offer proof books along with a DVD of edited pictures. A proof book is usually 8 ½ x 11 inches and is in black-and-white, always. Make sure this is in your contract so the clients aren't surprised when they get the DVD and it isn't what they expected. Be professional and make sure you and your clients are on the same page.

Establishing Your Hourly Rate

Establishing your hourly rate can be tough. The biggest question of your pricing structure is how much you should charge. Is it too much? Too little? Be honest with yourself with establishing your hourly rate—or your flat rate, if you decide to do that. How much are you really worth? Take some time to think about this and be fair to your clients. Come up with a comparable price that is affordable, yet allows you to make a profit. Be sure to take into account your out-of-pocket costs when determining your rate. You don't want to end up losing money at the end of the day.

Typical A La Carte Items

You can offer any combination of a la carte items. Again, take into account your time and expense related to these items when you determine what your costs will be for these services. Here are some typical a la carte items you can offer, along with some of the pros and cons.

- **Albums:** Albums are a high margin item and couples love them. The upside is that they are a great up-sell. The downside is that they can be a lot of work and take a lot of time.
- **Second shooters:** If you don't include a second shooter in your flat rate price, you should offer them as an "a la carte" item. Sometimes couples feel more comfortable if there is more than one photographer shooting, so it is a good idea to have this as an add-on. The pro is that couples like having the option of more than one shooter. The con is that the extra money charged for this service will most likely go to paying the second shooter and not provide a huge profit margin.
- **Prints:** Couples will oftentimes add prints to their package. If you use a site like Pictage, where guests can also buy prints, they are a definite up-sell. Prints have increased my revenue a lot and I can't say they have any cons, only pros.
- **Additional hours:** If a wedding is going to start extra early or end late, you want to have the option of charging extra for any hour(s) above your set coverage. The perk of this is that it is an automatic a la carte item and can add to your overall revenue. The downside is that you know you're going to have a twelve-hour day.

- **Retouching rate:** If you offer retouching in your package, how long should it take and how much should you charge? I offer light retouching if needed or requested. I am pretty fast and good at it, but if the image requires more than just cosmetic retouching, I will farm out the work to someone more qualified and invoice my client for the service. Typically the fee is $125 per hour, and depending on the extent of the retouch request, that covers one image but never more than three images.
- **Traveling outside a specified radius:** Coming up with a specific radius that you travel within is a must. If you go outside that radius, it will cost extra. This will help cover gas and any maintenance on your car that is required.

The Costs for an Average Wedding

Typical wedding-day shoot expenses look like this:

Gas, parking, and tolls	$75
Second shooter	$350
Event cards	$100
Editing of wedding/postproduction	$300
DVD and cover with design	$75
Proof book	$250

In addition to all of these costs, I then amortize the yearly costs of insurance, office supplies, equipment repairs, etc. to each wedding. On the personal side, I always have childcare expenses, too. My average expenses per wedding are $1500. So when I am pricing a wedding I have to, at the very least, double my expenses before I really make any profit. I find that most weddings, when the couple has an album included in the package, average about sixty hours of work. Once I calculate all the expenses and account for all that I take in on a wedding, I am making about $25 per hour. Some of these expenses may vary, but overall this is how I gauge my pricing.

Wedding Contracts

Having a wedding photography contract is absolutely necessary. It protects both the photographer and the couple getting married. Coming up with a contract is simple and it can be tweaked at any time. Do your research as you develop a wedding contract and make sure you cover every single base you can. When I was making up my own contract, I asked some photographers I had assisted or second shot with if I could take a peek at their contracts. Looking at other photographers' contracts can be helpful, especially if you have no idea what needs to go in one. I also found contract templates through my photography associations. There is a copy of my sample contract in appendix B.

It is very important to be as thorough as you can when coming up with your contract. When I first started out I made the mistake of leaving specific information about deposits out of my contract, which ended up costing me money. I learned my lesson, and now I require a 50 percent nonrefundable deposit to secure the wedding date. By adding the "nonrefundable" to my contract, I ensure that if for any reason the couple should break up, I don't owe the whole deposit back.

Set up an appointment with your lawyer to get help developing a contract with correct wording and structure. It is important to have a document that is set up correctly and goes over absolutely everything you need to cover. Make a list of everything you need to go over before you meet with your lawyer. Take a few days to think about it, because new things will pop up. Coming up with a contract takes time and you will always be updating it or changing things—it is never set in stone. If you decide to write the whole contract yourself, it might be a good idea to have a lawyer look it over or have someone with experience in law make sure that everything looks okay. The contract that you will be giving to clients to sign is important, so you want to make sure everything is perfect.

What To Do Once the Contract Is Signed

Once I receive the original signed contract back with the 50 percent deposit, I do the following:

- E-mail the clients letting them know that I am in receipt of the contract and deposit.
- File the original contract in the folder that has been created for that client. I label the folder with the bride's last name and the groom's last name and

their wedding date. I file all my folders in a date sequence, not by name. I have all my wedding contracts in pink folders and my events in yellow folders, but they are all in order by the date.

- I deposit the check into my business checking account and I copy the check and deposit slip twice. Once copied, I put one in my "deposit folder" in my business filing system, and the other copy into the clients' folder.

- I then create a client file of the bride and groom for invoicing purposes. Typically my contracts on weddings require three payments. I program Quickbooks to generate an invoice thirty days prior to the due date of each of my clients' weddings.

- I add my new clients to my database.

- Finally, I put the clients' wedding date in red on my calendar, so that I know that I am booked.

Finding Clients

My plan when I was starting out as a wedding photographer was to shoot as many complimentary photo shoots and sessions as I could afford. For the first six to nine months I photographed every event and person I knew of at no cost to my subjects. This was a huge risk in many ways, but I was fortunate enough to produce quality images, and this is what the folks I photographed told their friends. This is how I built my portfolio, and the people who allowed me to photograph them not only still allow me to continue to use the images that I shot seven to eight years ago, but they still send me a ton of business. I totally believe that you have to pay your dues, so to speak. I also did volunteer work and offered my photo sessions at silent auctions in some of my favorite charity events.

I built a large client base by giving away my talent and time. My main focus was event photography. Offering shoots to the philanthropic community was critical to building the "event" portion of my business. I broke even on weddings or did them complimentary to build and get images that I could use on my marketing brochures and website. I needed the experience, of course, but I also needed to have the work to prove what my skills were. I also second shot weddings and bar mitzvahs with established photographers. Some of them allowed me to use some of the images I shot in my marketing portfolios, and this was a huge help.

After you have started to build your clientele, you will need to market to them. Just because they are already clients doesn't mean that they will use you again or refer you to someone else they know. You also need to figure out how to gather new potential clients. One way to do this is to have a section on your website where potential clients can enter their e-mail addresses to be added onto your website's mailing list. Or you could simply have a place on your site that allows guests to leave their e-mail addresses if they are interested in receiving future notifications from you. Your website is a great way to find new clients, and to keep the ones you already have coming back for more services.

05 | Marketing

One thing you have to do when you start out as a wedding photographer is market yourself. It is absolutely necessary to use marketing as a tool to build your new business. Have you ever heard the saying, "You have to spend money to make money?" It's true. Someone must see a business name about ten times to remember it. You want people to know who you are and what your business is about: That is crucial.

Your Logo

Coming up with a remarkable logo is a strategy that helps people remember you and your business. You must maximize the amount of times they see it. You can use a logo in a lot of different places—on your website, your business cards, your brochures, your blog, in advertising, and in e-mails. When you have put your logo everywhere and people begin to see it, they'll start to recognize it, and therefore remember you and your business.

I created my own logo. People have always called me KJ and the colors green and yellow are my favorite. I wanted it to look really young and hip. The catchier and more modern it is, the easier it is to remember.

Once you have a logo, it will be easy to put together any marketing tools that you may need. Whether it is wedding brochures, business cards, or flyers for mail advertising, designing a logo will embellish these advertising tools. It is important to have all of these things in place when you first start your business because you never know when you'll need them. I carry business cards wherever I go. I stash them in my car, my briefcase, my purse, and my camera bag. You need to have them handy because you never want to be without one in case someone asks. Make sure you design all of these items so that they tie together and show off your creative side.

Having impressive business cards and wedding brochures will draw prospective customers to you.

There are websites that offer a "logo service" that oftentimes have packages that can include: logo design, stationery design, and business cards. A website called www.thelogocompany.net offers three different packages ranging from $149 to $289. Another site called www.quicklogodesigner.com allows you to buy a program that you can use to create your own logo. Another way to create a logo is to hire a graphic designer to collaborate with you on your business logo. I think that this is the best way because it really allows you to be involved in the process every step of the way and gives you the ability to design it how you really want to down to the smallest detail. These are benefits you might not get using a website or DIY program.

Business Cards

Business cards are essential for networking. Things to include on your card would be your logo, name (if not part of your logo), and contact information. One of the most important things to include on your business card is your website (more to come on that in this chapter). This way when you meet someone new you can say, "Here is what I do and you can view my portfolio at the website listed." You can also attach your business cards to price sheets and other marketing material that may not include your contact information. Including one of your photos on your business card is a great way to draw someone's attention immediately to your work. You can

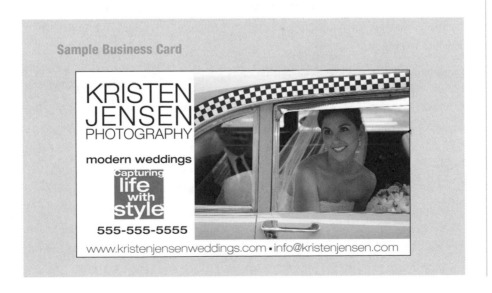

Sample Business Card

KRISTEN JENSEN PHOTOGRAPHY
modern weddings
capturing life with style
555-555-5555
www.kristenjensenweddings.com ▪ info@kristenjensen.com

have business cards made either by a local printer or by a printer on the Internet at sites like Vistaprint (www.vistaprint.com).

Wedding Brochures

A wedding brochure can be as basic as a one-page flyer or as elaborate as a bifold or trifold brochure. Brochures are beneficial for promotional mailings, wedding shows and expos, charity events that you are photographing, and to leave with vendors for possible referrals. You will need to weigh the cost against the benefits to see if a brochure is right for you.

The key elements to include on a brochure are your logo, contact information, promotional copy, and a sampling of your best photos. For the promotional copy you can either talk directly about your skills or provide insight on your photography style. The copy should be short and engaging to capture your prospective client's interest. For the photos, try to tell a story or tie in a theme. Your goal is to hype your photography and creativity, not overwhelm with too many photos. On the facing page is an example of a brochure I created to showcase my wedding photography.

Creating Your Website

Having a great, easy-to-navigate website is critical in this type of business. It would be hard to build a new business without having one. A website is a great way for prospective clients to get to know more about who you are and your style of photography. It is a good way to show off what you do best—think of it that way. It is the first impression a couple will have of you as a photographer, so an impressive website is a must.

When you're designing your website, think of it as your storefront. How do you want people to feel when they see your pictures? How do you want to come off as a photographer? How are you going to draw clients in with your site?

I started my website, www.kristenjensen.com, in 2003, when I first started as a wedding photographer. The web had just exploded and my site was much more modern than a lot of my competitors'. This helped me to get my first paid bookings— by being different. I interviewed several graphic designers before choosing one that I thought would best help me accomplish my goals. Since I had a very clear vision of how I wanted my website to look, I needed to find someone who I knew could make it happen. It was important to find a great graphic artist because she really shaped how my business began. I still use the same designer today, and I don't regret it.

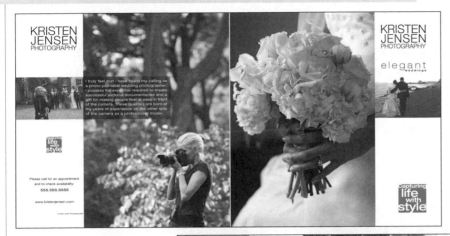

There are ways to create a professional-looking website without hiring a graphic designer. One site, called liveBooks (www.livebooks.com), focuses on creative small businesses, and helps you create your own custom, predesigned website. This site allows you, the business owner, to focus on managing and developing your business instead of concentrating on designing your website. Another option is a similar site called intothedarkroom (www.intothedarkroom.com). They have two options as far as building a website. They offer products sold separately, like predesigned websites, blogs, and slide shows. On the other hand, they offer completely customizable websites with the options of blogs and brands as well.

No matter how you decide to go about it, creating a one-of-a-kind website is a necessity for your photography business. There is a lot of competition among wedding photographers and you need to be seen differently than the rest if you want to start booking jobs. Remember, when you're designing your site, to think of it as your storefront. How are you going to get a potential customer into your store?

Search Engine Optimization

Search engine optimization (SEO) is a process that improves the visibility of your website in a search engine. Search engines are one of the primary ways that someone on the Internet will find a website. Typically, they will search using a couple of main keywords to find a site they are looking for, and a bunch of listings will show up from the search. The higher up your website is on this list, the better the chances that someone will go to your site. SEO means making sure that your website is accessible to many search engines and that it is "focused" enough that it is found easily.

SEO is considered an unpaid Internet marketing strategy. Some specific SEO tactics go into the website design process and development process to improve its search availability. It is important to find an IT professional or someone that

SEO Expert Tip

"The first and foremost change you can make on your site to drive more traffic is continually having new updated images with text. The second is naming your images a name that search engines look for. Such as, if it's a portrait of a baby, do not use the client name for the file name. Rename it something like Baby Portrait."

—Robert Braathe, SEO and Mac Specialist

specifically works on SEO for your site. I hired my SEO guy, Robert Braathe, two years ago and my site went from 500 visitors a month to 18,000. An SEO expert can help you figure out how search engines rank web pages, and the location and frequency of keywords on your site. It is important to work with someone who has experience in this line of work so you can maximize your website's potential.

Social Networking

In this day and age, it is imperative to use social networking tools to market your business. You need to get yourself out there.

It seems as though everyone has a Facebook account these days. Uploading pictures from shoots and tagging the bride, groom, and some guests is important because then all of their friends will see the pictures and can be linked back to your Facebook account, where they can view more of your work. This might tempt them to check out your website, and the next time their friends say they're looking for a photographer, they might mention your name or tell them to look at your site. Social networking is a free, fun, and easy way to get your business seen by thousands of people in one place.

I also have a blog. This is what the search engines love. My blog is on all photography shoots, including weddings and events. I also write about things I'm up to and different ideas. Not only do the search engines like photos, but they like words, too. I update my blog a couple of times a week. The blog is really great because it connects to all my social media: Twitter, Facebook, and LinkedIn. I blog about jobs I've done, talk about the shoots, and give more details. The more I talk about things I do, the better chance I have to get my name out there. I blog about all the different types of photography I'm doing, and I link sites of my clients to my blog. It's kind of a win-win thing. I talk about where the bride got her dress, the florist she's going to use, the jewelry she's wearing, the car the couple rented, the band they hired. It's good for potential clients to look at. The blog is almost more critical than your site because it's more current. I got more visitors to my site because of my blog.

Twitter, Facebook, and LinkedIn have really improved social networking for me. Anyone looking at my blog can be connected to my Facebook, Twitter, or LinkedIn accounts instantaneously with the click of a button. Being connected through more than one social media tool has expanded not only my client base, but also the type of clients who have become interested in me. Since a lot of these networking sites are targeted toward a younger generation, I have seen a dramatic change in the ages of clients who contact me for more information about my business.

My Blog

This is a shot from a bride getting ready with her bridesmaids. A perfect "getting-ready" must-have shot. I love the light and naturalness of the bridesmaids and bride.

Advertising

When I first started out as a wedding photographer, I had to advertise everywhere to get my name known and to start booking weddings. It is so important to advertise when you first begin your business because no one knows who you are. But if they see your name somewhere—in a magazine, online, on your company sign, on your business card, on your magnet sign on your car, or at a venue—they might become interested enough to go to your website. There is paid advertising and free advertising, and I think it's vital to do both. I used to do paid advertising, but now about 80 percent of the clients I get are from word of mouth. The other 20 percent is from Google searches and free website vendor listings.

I have paid to be featured in *Modern Bride*, *The Knot*, and *Grace Ormonde Wedding Style* magazines. I have also paid to be on bridal websites like brides.com and

my connecticutwedding.com. Paying for advertising can be expensive, possibly running up to as much as $15,000 a year. It may be necessary, though, when you're first starting a business. You can also choose to advertise on free websites like wedplan .net or weddingwire.com, which I still use. This site lets you have a blurb about your photography business, some pictures, and your contact information. It is also linked to your social media pages, which is nice.

When you pay to advertise, sometimes you can request a list of the names and addresses of brides that are getting married in your area. If you can obtain this list, you can do direct mail advertising. Having something you can mail, like a flyer, to these potential clients is important. I think it is even more important to do a direct mailing because so many of your competitors will not. You need to design, or get help to design, a page that has some pictures, your contact information, and your logo to send to these newly engaged brides. Often brides don't have a specific photographer in mind, so if they get a flyer in the mail about a respectable photographer in their area, chances are they will check out your website and possibly refer you to a friend.

E-Mail Blast Advertising

Another type of free advertising is e-mail blast advertising. It's free and it is simple. I try to do an e-mail blast about once a month. In order to do e-mail blast advertising, you need to build a database on your computer of people you meet. I collect businesses cards everywhere I go, and add them to my e-mail database. I had about 3,500 e-mail addresses when I wrote this. It's important to do e-mail blast advertising because it's easy and can help direct people to your website. You never know who needs what.

Word-of-Mouth Advertising

The best marketing comes through personal relationships and word of mouth. The one way to do this kind of advertising is to research local wedding venues and reception sites. This is the order of how things roll: Usually a couple will get engaged, set a date, choose a venue, then choose a photographer. The best place to get a referral is from wedding venues. Cultivate relationships with managers at places for weddings. Update them with pictures, give them a book, brochures, and business cards. This is imperative. It is a good idea to concentrate on an area that is within twenty-five minutes of your home office, or at the type of venues you enjoy shooting at. You also have to remember to update them so your information is current and not

dated. It is a good idea to give these wedding industry colleagues photographs that showcase their venue, because it will show the venue in the best light possible. It is a win-win situation. It is also a good idea to reach out to florists in your surrounding area, in case the bride chooses the florist before the photographer.

E-mail blasts and blogs work with word-of-mouth advertising, especially in today's digital age. When people go online and see something they like or get an e-mail they are interested in, they usually want to share it with friends or family. Whether a client forwards an e-mail blast I send out or gives out a link to my blog, it helps get my name out there more and more.

Get yourself out there, meeting people as much as possible, and it will be easier to find potential clients. People constantly refer vendors with whom they've had a good experience to their friends and clients. I pride myself on my business and believe that I limit the amount of negative views on my work by having a great work ethic, being confident in my work, and delivering great photographs. Keeping a good reputation is critical, because when you send out e-mail blasts to clients, they will mention your name to their family and friends. It is kind of like a revolving door, because clients keep going around and never really leave.

Business Signs

It is a matter of personal preference as to whether or not you want to put business signs on your car or in front of your home. For me, it was a matter of getting my name out there even further. I live on a road that has a decent amount of traffic, so I decided that having a Kristen Jensen Photography sign would benefit my business. Also, since I have my studio in a building behind my home, a business sign made it easier for clients coming over for a meeting to find me. I chose simple, easy-to-read signs because I didn't want to get complicated. I didn't want people slowing down as they drove past my house trying to read what my sign said.

If you live on a dead-end road it might not be beneficial to have a sign, but it is something to think about if you run your studio out of your home. It is a definite must if you live on a somewhat busy road—you never know who will drive by. Remember to check with your town hall to see what rules apply to putting up signs in front of your home. I had to go to my town to get permission before I put them up. You also must have a permit to run a business out of your home (see chapter 4 for details). Call your town hall before you have signs made to make sure you take the proper precautions before putting them up.

I also have magnets on my car to promote my business. At first I thought it was silly to do such a thing but more and more people are advertising this way. It's important when you're driving around town, since a lot of people will see your car. Also, when you show up at weddings, you look more professional and guests see your sign when they come to the church or the reception. It's amazing how many people say to me that they've seen me driving around and looked me up online, or that they've seen my signs and remembered my name. I've proved that it can work for me—see if it will work for you too.

Marketing Plan

Coming up with an action plan for marketing is the best way to start generating ideas on how to get the word out about your business. It is best to brainstorm ideas, think them over, and get advice from friends to see if they think your idea is worth trying. You want to make sure that you don't cross the fine line between informing your clients and annoying your clients. Having a marketing checklist is a great way to stay on top of things.

Marketing Checklist

- ❏ Do you have a marketing plan and budget in place?
- ❏ What percentage is online marketing?
- ❏ What percentage is direct mail marketing?
- ❏ What percentage is album or preferred vendor marketing?
- ❏ What is the cost for development of your website?
- ❏ What is the cost of your wedding brochure?
- ❏ What is the cost of your business cards?
- ❏ What is the cost of having your website optimized?
- ❏ How much do you plan to blog on your site?
- ❏ How many bridal shows will you attend this year?

06 | Publicity and Public Relations

What are public relations and how do they pertain to your wedding photography business? Simply put, publicity is attention in the public eye or media. Public relations are a way to enhance the way someone or something is seen to the public. Public relations (PR) can help a business by giving the public a better understanding of what a business is and what it provides to its customers.

Publicity and PR go hand in hand. Good publicity and PR can show your wedding photography business in its best light. Having your business publicized can build your reputation in the eyes of your community. It is essential to the future of your company to have a good standing with the public and to be publicized in the best light possible. Ensure good PR by submitting photos to local newspapers and magazines, and from there hopefully you can shoot local events and get a photo credit.

Getting Involved Locally

The best way to become known is to get involved with your town and any close surrounding towns. Getting involved in local charities, events, and fundraisers is a great way to network and meet a ton of people. Offer to shoot these events for free, or for a small price. This can be a huge opportunity to showcase your work while doing something good for your community. It is a total win-win situation.

When people attending these events see how you work, and then see the quality of your photographs, there is a good chance they will use you if they ever need a professional photographer—or they will talk about you to their friends, which will help get your name out there. By being involved in local charities, you're also showing that you care about where you live and

are passionate about certain subjects. People will admire you for this. These types of events are great fun to shoot and a must when you are first starting out. It will help out in every aspect of your start-up: getting known, getting good pictures, and meeting new potential clients.

Getting involved locally is simple. There are websites, like www.americantowns .com, that make it very easy. AmericanTowns is a website that allows you to search a community and its local events, town issues, and community activism. This site is a great way to stay on top of what is going on in your town. Browse it occasionally, and if something catches your eye, either make a call to whoever is putting together the event, or show up and introduce yourself to key players. If you're lucky, you can get permission to shoot the event, gaining experience and adding to your portfolio. Even if you aren't able to shoot, it is a good idea to attend events in your town to meet important people, introduce yourself, and mention what you do.

If you support any charities, look up a chapter near or in your town that you can get involved in. That is what I did, and I have been fortunate enough to shoot a ton of events hosted by them. For example, I am involved in Susan G. Komen for the Cure and I have been to many events, which has led to shooting an exhibit for some of the survivors for breast cancer locally.

Joining Your Local Chamber of Commerce

Another good way to get involved is to join the local chambers of commerce. I am a member of the Bethel, Ridgefield, and Danbury Chambers of Commerce. A chamber of commerce is somewhat like a business network. It is an organization of businesses that advocate on behalf of their town's business society. It is important to join your local chamber to meet other business owners. Meeting local florists, jewelers, bands, reception halls, and other local photographers is essential. Developing personal relationships with them is a must—to get business you need to help each other out. It's like a big circle—you refer clients to them, and they will reciprocate.

Fundraisers

I support and have been very active in the Susan G. Komen for the Cure foundation, as well as many others. It is important to choose charities that interest you and that you really support. I held an event called "Drink Pink, Think Pink," which was held in the next town over from mine. It was a community event to raise money for the

Susan G. Komen for the Cure in Connecticut. A bunch of local business owners and I got together to make this event happen and we raised more than $10,000 for breast cancer research. I got to feature a collection of photographs I shot called "The Survivors," which was a beautiful collection of black-and-white portraits of breast cancer survivors that showed strength, courage, and hope. I had twenty-nine 24 x 36-inch pieces hanging in the show.

Not only was it a wonderful experience, but also my business got a lot of publicity. I also met a lot of residents from the area, who got to see my photography and learn more about my business and me. It was a great opportunity to get my work out there but also do something good.

I brought a lot of business cards with me to the event, and had them out so people could take them. Although it wasn't wedding photography, people could still see me as an artist and see my work, which is the most important thing. If they need a wedding photographer or know someone that does, chances are, after an event like this, they would refer them to me, which is all I can ask for.

Getting in the Press

Another good way to get your name out there is to be featured in a local newspaper or magazine. Most towns have some sort of publication that is home-delivered or can be picked up in the local convenience store. These types of publications are always looking for interesting stories about the people who live in the surrounding areas. A lot of these articles are featured online as well, which will give your business even more publicity. This ties in with shooting for local events and fundraisers because these types of occasions will likely get a lot of press, which could potentially lead to an article about the photographer shooting a commendable event, rather than the event itself.

There was an article written about me in the *Connecticut Post* in 2008 called "Brave Faces," which was about an exhibit called "Faces of Courage" about nine breast cancer survivors. It was another fundraiser for the Susan G. Komen for the Cure foundation. This was a once-in-a-lifetime shoot for me. Meeting these nine women was beyond inspirational. I absolutely love that I can do something I am so passionate about, and help raise money for such a good cause. It's a great feeling to help in this way. As a photographer I felt so lucky for the chance to meet people like these women, and get to know them. Then, to top it off, having an article about the experience appear in the *Connecticut Post* was a dream.

Most of the time, local town newspapers are looking for photography submissions. You can go about this a number of different ways.

First, you can do an online search of all of the local newspapers around you. Make a list of five to ten, and jot down their numbers or e-mail addresses. E-mail or call each one to introduce yourself and inquire if they are looking for a freelance photographer. You might even be able to find this information online. Explain that you are looking to submit photographs and ask if there is anything in particular that they want/need/are looking for. Be proactive, because even if there is nothing online about photo submissions, calling or e-mailing will help you determine what they are looking for, if anything.

Most small newspapers don't have a huge staff, and they might not even have a photography director, so try to contact the editor or whoever is in charge. Submitting photographs can sometimes lead to a steady freelance job, which could be great for you as a budding photographer. It is hard to put yourself out there and offer services for free, but it will pay off eventually.

Other newspaper articles have also been written about me: I was featured in *The News Times* and *The Ridgefield Press*. Both articles were about my evolution from a model to a professional photographer. I also was featured in an article called "Photographer Places Clients In Best Light," in *Inside Business* newspaper. You have to be very proactive as a business owner. The reason I have had such good luck with publicity is because I put myself out there. It is incredibly important to do that. Especially as a photographer—there are so many that you need to be different, to set yourself apart from the rest. Being a big part of your community is a great start.

Submitting Your Work for Editorial

Submitting your photos to local magazines is another great way to be seen. I have submitted to two local magazines that have printed my photography, and it has really helped my business grow. You can also try to submit your work to wedding magazines and wedding photography print competitions. Wedding magazines are looking for something different, something really interesting. Most of the time, they

are looking for a story. If you can come up with that, that's great—you should try to submit as many as you can. If you want to just submit photos, competitions are great publicity.

Something to remember: If you advertise in a magazine, they are more likely to publish your photos. Even if they publish them online, it can really help.

Vendor Relationships

I can't tell you how important it is to develop relationships with the owners of other local wedding businesses. Every wedding pretty much follows the same pattern. Each wedding is going to need a venue, music, flowers, rings, and a photographer. Typically, there is an order in which a bride and groom will decide where to get these things, but sometimes there isn't. Usually the couple will pick a date and a place first. After that, the photographer!

The client chooses his or her photographer in the early stages of planning because it is a huge part of the wedding day and the only way to remember it. It's important to develop relationships with other wedding business owners because they will refer brides and grooms to you. If a couple is checking out five different venues for their reception, and they see your card or hear their guide mention your name in more than one location, chances are the couple is going to remember your name. I can't stress enough that having good relationships with these vendors is crucial!

Other good relationships to have in this line of business are with your local churches and synagogues. Most of the time a couple will want advice from as many people as possible to help plan their wedding. If both a reception venue and a church mention your name to the couple, then that's a huge help.

Even though a couple might interview more than one photographer, the one that everyone mentioned will most likely be who they choose. Since this is one of the most important days of their lives, they want the best that they can find and afford, because they want to remember the day through pictures. Develop good relationships with other vendors, and I can guarantee that it will help your business.

Wedding Photography Associations

Being part of wedding photography associations will help you to be successful in your business, too. These associations include the Professional Photographers of America (PPA), the National Association of Photoshop Professionals (NAPP), and the Association for Wedding Professionals International (AFWPI). Being a part of these

List all vendors you work with on each wedding. Make sure that you get the names of venues, florists, bands or DJs, wedding planners, and anyone else who might be involved.

	Vendor Name:	Possible Photos	Possible Referral (yes or no)

Venue: _____

Florists: _____

Band or DJ: _____

Wedding planner: _____

Jeweler: _____

Videographer: _____

After you edit the photos of the wedding, make separate folders with images that pertain to each vendor at that wedding.

Reach out either via e-mail, or better yet with a phone call, and make appointments to meet the vendors. Let them know that you have images that would be useful for them. When you meet, show them your work, give them the images that you took at that particular wedding, and leave a stack of your wedding brochures and business cards.

Then add these new contacts to your database and keep in touch with them by e-mailing them your newsletters.

Refer them to your potential brides and grooms during the interview and after you book them.

Thank your vendors when they send you business with a handwritten thank-you note.

associations really helps to build your resume, so to speak. It is also beneficial to join for the benefits. Numerous competitions, conventions, and workshops, as well as legal advice, are available to you if you join. Attending these conventions and workshops is useful because you can learn a lot about your trade and improve on your craft. Entering contests offered on the websites is good publicity because it shows

you are competitive and that you shoot great work. It's also something that you can brag about with your clients. Joining associations helps you grow as a photographer, and will help you meet fellow photographers. It is important to know your competition. Remember to: "Keep your friends close and your competitors closer."

Shows and Expos

There are probably a lot of wedding showcases and bridal shows in your area that you never even knew about. Researching these events and participating in them can be a huge step in the right direction for your business.

Chances are that any big venue near you will host wedding events many times a year. To be a vendor and get a booth costs about $500 per event. This is a prime opportunity to meet brides who are looking for photographers, to show them your portfolio, and to give them a business card. It's a great way to find potential clients

because you actually get to meet and talk with each individual bride. It's also, in some ways, better than your website because clients get to meet you face to face, and if you are very personable, this could be a great opportunity.

Wedding shows and expos usually coincide with the "wedding season," give or take a few months. They usually start a few months before the wedding season, allowing brides and grooms to gear up for the upcoming months. Sites like www .greatbridalexpo.com give you national listings for shows from January through April. By simply going online and doing a search of wedding shows and expos near you, you can start a grand list of the dates and times of each expo/show that is in your area. Choose three to five shows that you definitely want to register for and set up a booth at. You can sign up for these shows on the website. Usually you click to fill out an application form, and then a representative will contact you regarding exhibiting with them.

Sometimes a client prefers the phone or e-mail for means of communication. This is fine but you should meet your couple in person at least once before their wedding or engagement session. There are many perks to meeting a couple, but the most important is that you get to know them and they get to know you. A first meeting can be nerve-racking, but remember that a client is just as nervous to meet you. Typically a couple will meet with more than one photographer, to "interview them" before booking one of them. These tips and advice for meeting a couple for the first time will help ensure that they book you to shoot their wedding.

Setting Up an Appointment

Usually a couple has heard about me from someone they know. They will either call me or e-mail me to schedule a time to meet. At this point, the couple has most likely looked at my website to see if they are interested. Setting up an appointment to meet and talk more about the wedding is important for booking a shoot. It is very rare that a couple will just look at your site, book you right then and there, and send you a check. I can count on one hand how many times that has happened.

I like to meet my clients on the weekend, preferably Saturdays, because the meetings tend to be more laid back and relaxed. I don't like meeting couples during the week because it is usually late, after they get out of work, and everyone is tired and not really focused. Sometimes I'll schedule meetings back to back on a Saturday to make things easier for me. That way I can stay in wedding mode all day and it is sometimes easier to get work done this way.

After I set up a meeting with a couple, I always e-mail them to confirm the day and time of the appointment, especially if we booked it far in advance.

How to Set Up Your Home for a Meeting

Meeting a client for the first time can be nerve-racking because you want to make a good impression. I know it's pointless to say this, but don't be nervous. There are things you can do to prepare yourself for this meeting, so you can relax.

Whether you have your meeting space inside your house or in a detached garage, you want to make sure the space is neat and tidy. Think about where you will be meeting clients ahead of time. Set up a space specifically for meeting clients, whether it is a spare room or your office. If you don't have this type of space, a dining room will work. The way you set up the space you have is what counts.

I use my studio, which is in a detached garage in the back of my house. I have parking specifically for clients and a separate entrance to my studio, so you don't have to walk through my house. Luckily, because of the way my house is set up, I can do this. It looks professional.

If you decide to use a room in your house, make sure you choose one that is airy and light, and maybe close to an entrance.

Staging the room for a client meeting or presentation is important. It is like designing your website. How do you want to be portrayed as a photographer? What image do you want to give off? How do you want the couple to feel when they enter? Decorating is completely up to you, but my advice is to keep everything simple. I have a bunch of my photographs framed nicely and hung across the back wall of my studio. My whole set-up is black-and-white, so my photos are all black-and-white as well. My clients face outside, with me across from them. I try not to make it seem like we're in a meeting but just getting to know each other and having a nice conversation.

I treat my clients like I would any guest in my house. I offer them something to drink and always have a snack on hand in case they want something to eat. This is the polite thing to do, even if they aren't hungry or thirsty. It adds a nice touch and can enhance the mood in the room. I also like to light a candle on the table to give off nice scents and a good glow. I also have some really great music playing . . . People always love it.

Setting up your space for meetings is totally up to you. Keep in mind the kind of image you want to portray and how you want to come off to the couple. Other than that, it is important to be yourself, and let your personality come through. Getting a second opinion or help from a friend is always a good idea. Making the couple comfortable should be your first priority; you want them to feel as relaxed as possible.

Everyone's lives are hectic and it is easy to forget or pencil in the wrong time. Make sure you are all in agreement on the day and time so there are no mix-ups. It also shows a couple that you are organized and professional.

Day of the Appointment

Having a clean and tidy space to meet is essential. Make sure the day of the meeting that your work space is picked up and clean. If you have pets, make sure they are out of the way in case your client is allergic or doesn't like animals. If you have children, make sure they are at a playdate or aren't going to interrupt while you meet with the couple. I like to dress in jeans and a crisp white shirt for my meetings. Since I like to schedule the appointments for Saturdays, I think jeans are appropriate because they are more casual and relaxed. I make sure I look presentable, classic, modern, and put together. Make sure that you have everything you may need accessible and in the room where you will be meeting. Being organized is a plus for couples and gives off a good vibe.

Agenda for the Meeting

When I first meet a couple I like to ask how they met and how long they've been engaged. Being interested in how they became a couple is always fascinating and can make aspects of your job easier as a photographer. I also like to find out how much of their wedding is planned. Oftentimes the couple is looking for referrals for other things, like a band or a great florist. Being a wedding photographer, they trust that you know what you're talking about and can give them a few names.

In the back of your mind you should have a list of important things to go over with the couple. I don't necessarily follow an agenda, but there are some things I like to go over to make sure that we're all on the same page. Most importantly a couple and the photographer should be able to agree on things before they work together. I go over how I work to make sure that works for them, including my shooting style and the time I plan to arrive on their wedding day. I walk through the day as if I am already working for them, going over every detail and how I would handle certain situations. I let them know that I always like to speak with clients on the Monday before the wedding to go over our photo plan. Typically, by five to six days out, we have an idea on weather. Plan A is if things go smoothly, and Plan B is what to do if something doesn't go as planned. I also like to go over the contract to make sure they don't have any questions. I have a form (see Client Set-Up Worksheet on the next page) that I use at each meeting that has certain information I need on it, like

KRISTEN JENSEN
PHOTOGRAPHY

123 Main Street,
Any Town, CT
USA
555.555.5555
e-mail
www.kristenjensen.com

today's date_____

bride's name _____

address _____

phone _____

cell _____

other _____

e-mail _____

groom's name _____

wedding date _____

ceremony location _____

time of ceremony _____

reception location _____

time of reception _____

number of guests _____

no. of members of bridal party_____

whom should we thank for referring you to us?

for in house use only: _____

where the couple is getting married and the date of the ceremony. I always have a clipboard that I jot notes down on.

When I'm talking to a couple, I act as though they've already chosen me and that I'm going to photograph their wedding. Even though they may be interviewing more than one photographer, pretending that they've already hired me helps make it exciting and more real. I have a checklist of shots (see the Client Shot List Worksheet on the facing page) that I go over to establish what photos the couple wants. At the end of the list is a special section for other notes. I find that oftentimes a couple has a specific picture in mind that they must have. Catering to their needs is important as a wedding photographer, because this is their special day and you want to do everything in your power to make sure you capture every moment.

During the meeting I like to present a slide show of some of my wedding shots. I also like to have on hand some of the photo albums that the clients can order, so they can look at them. I also have a selection of proof books available for the couple to look at. Choosing the pictures you want to show a couple can be tricky. I like to show them a wide variety. After showing my work, I go over the different packages I have available and things that they can add to them. I also talk about the engagement session and whether or not they want one. I typically add an engagement session to close and get a signed contract. About 50 percent of the brides and grooms I meet want a session. Each couple is different, so it is important to let them know how you do engagement shoots so they can decide if they want one or not. This is also a good time to go over specifics like whether they would like a second shooter or not. I prefer to have a second shooter if there are more than two locations on the wedding day and if the guest list is over 150. I explain this to the bride and groom.

It is also a good idea to go over any questions that the couple has at the first meeting. The question I get the most is, "What happens if you don't show up or if you get sick?" In the eight years I have been a wedding photographer, I have not missed a wedding (knock on wood). I tell the couple this, and also tell them that my contract states that if I am unable to attend for any reason, I will have someone with equal experience shoot their wedding. It is important to make a couple feel that you are reliable and can be trusted. I also have a testimonial page on my website and on my social network sites for clients to view. Often a couple will ask to see client testimonials or a client referral list. It is important to have these handy so you're prepared if they ask. Not every couple will ask, but if they do it is better to be safe than sorry.

KRISTEN JENSEN
PHOTOGRAPHY

Special instructions for photographer

Please provide a selection of required photos below. We will make every effort to capture each item selected.

Traditional Photographs:

- ☐ Bride
- ☐ Bridesmaids
- ☐ Bride's parents
- ☐ Bride's siblings

- ☐ Groom
- ☐ Groomsmen
- ☐ Groom's parents
- ☐ Groom's siblings

- ☐ Bride's step parents
- ☐ Groom's step parents
- ☐ Total bridal party
- ☐ Total families blended

- ☐ Other: _____
- _____
- _____
- _____

Pre-ceremony:

- ☐ Bride getting ready
- ☐ Maid of honor
- ☐ Bridesmaids
- ☐ Mother of the bride
- ☐ Father of the bride
- ☐ Bride's siblings

- ☐ Groom getting ready
- ☐ Best Man
- ☐ Groomsmen
- ☐ Mother of the groom
- ☐ Father of groom
- ☐ Groom's siblings

- ☐ Bride's step parents
- ☐ Groom's step parents
- ☐ Total bridal party
- ☐ Total families blended
- ☐ Car/carriage
- ☐ Flowers

- ☐ Other: _____
- _____
- _____
- _____
- _____

Ceremony:

- ☐ Guests
- ☐ Bridal party
- ☐ Flowers

- ☐ Ceremony
- ☐ Officiant
- ☐ Rings

- ☐ Kiss
- ☐ Location
- ☐ Receiving line

- ☐ Other: _____
- _____
- _____

Reception:

- ☐ Introduction of bride & groom
- ☐ Bridal party
- ☐ First dance
- ☐ Father & bride dance
- ☐ Mother and groom
- ☐ Best man toast

- ☐ Other toasts
- ☐ Table settings/flowers
- ☐ Groups at tables
- ☐ Uncut cake
- ☐ Cutting the cake
- ☐ Throwing the bouquet

- ☐ Garter removal
- ☐ Leaving reception location
- ☐ Other:_____
- _____
- _____
- _____

☐ Other: _____

Please note that Kristen Jensen and her assistant(s) will take their break when all guests are seated for dinner and the toasts have been made.

I insist on having a second shooter for events and weddings that are over 150 guests, and/or if there will be multiple locations on the wedding day, such as the bride's home, the church, and the reception. It's great to have a second shooter go to the groom, groomsmen, and his family prior to the ceremony. Also, it's great to have two photographic perspectives on the ceremony. I am always at the end of the altar on the right side (the side closest to the bride). Often I'll have my second shooter in front of the church while the bridesmaids, bride, and father of the bride arrive. If there is a balcony in the church, that is a great perspective to shoot from.

My rule of thumb is to put my attention on the bride and her family. I ask for my second shooter to follow and shoot the groom and his family. It works out great this way. When we go into postproduction it makes for a nice ceremony story when we have close-ups of the bride and groom to put together in sequence. Typically, during formals, I ask my second shooter to start photographing cocktail hour. If there is a substantial time between ceremony and reception, then my second shooter will assist me on the formals. During the party and reception there is usually so much going on that the more photographers there are, the better.

These are the points I bring up to perspective clients who question the importance of having an extra photographer on their wedding day. Usually once I explain all of these points, the couple is very understanding as to why it is so important to have a second shooter. For weddings at a guest count of 250 or more, I have two second shooters.

Follow-Up

After meeting with a couple, I send them a thank-you e-mail within twenty-four hours. This shows manners and professionalism at the same time. Thanking them for coming over and taking time out to meet with me is important because it lets each couple know that I am interested in being their wedding photographer. Doing a follow-up e-mail is also nice because it lets the couple know that they are significant and not just "another" couple that I meet.

Usually within the week the bride or the groom will contact me via e-mail or phone to let me know that they chose me. At this point I put together a folder with the bride and groom's names and date of their wedding, and put in it the form I took notes on and their shot list. I also send them a letter in the mail containing two copies of my contract. One is for their records and one is for them to sign and send back to me. I sign one of them and put a sticky note where they need to sign—making sure to address which one they keep and which one they send back. I also include a self-addressed stamped envelope to make everything convenient for them. I had my own stationery made for this purpose, including envelopes with "Kristen Jensen Photography" on them. I also have pens and sticky notes with my name and logo on them. This is a nice touch that shows couples that you are really committed to what you do.

In order for a couple to book with me I ask for a 50-percent deposit down, which is nonrefundable. When they send the envelope with the contract back to me, they must include a check for half the amount of the whole wedding contract. I also talk to the couple about whether they want to do a payment plan or pay the rest in full right before the wedding. I usually break down the remaining balance into two payments. The second payment is due sixty days prior to the wedding, and the last payment thirty days before the event date.

Meeting a client can make or break a deal, so make sure you do everything in your power to book that wedding.

Engagement Session and Rehearsal Dinner

The beauty of shooting an engagement session rather than an event is that you can change the date if need be. If it's raining or snowing that day, you can reschedule. The majority of the sessions that I like to do are outside, so sometimes rescheduling is necessary. I like to shoot engagement sessions that are about the couple and who they are. I'm more liberal with black-and-white images for an engagement shoot because I feel the whole experience has more creativity and more freedom to it.

Engagement shoots can be tricky because 98 percent of couples walk in completely nervous, even if you've met with them before. The first thing they say is, "I never look good in photos," or "I hate having my picture taken." I hear it so much that it doesn't faze me anymore or put me off—I embrace it. If you act totally relaxed and just talk to the couple normally, the session ends up being completely natural, and in the end they say, "That was easy," or "That's it?" Most of the time the couple gets so into it that they don't want the shoot to end. I think most couples don't realize how quick they are, so they're taken by surprise at how easy and simple they are to shoot.

Should You Offer an Engagement Session?

I would say that for about 50 percent of the weddings I shoot during the year, I also do the couple's engagement session. I very rarely shoot an engagement session if the couple has not also booked me for the wedding. Most of the time an engagement shoot is something that I include in my wedding package, but I will also use it sometimes to close a deal. If a couple is on the fence about booking me for their wedding, I like to include an engagement session to help them decide. To me, it is better to do a free engagement shoot than to lose out on a whole wedding. If a couple doesn't want an engagement shoot,

then I usually include something else that is comparable in price, such as prints or a gift credit.

It's important for a wedding photographer to get experience doing engagement shoots because a couple that wants to book you for the wedding can also use you for this additional service. Couples find it very convenient to use only one photographer and pay one price. Whether you decide to include an engagement session in your pricing or offer it a la carte, couples would rather book a photographer that can do both. It is not only beneficial to the couple but also to you, the photographer. It can help you close deals and gain a higher interest in your business. But ultimately, offering engagement sessions could help raise your income.

Benefits of an Engagement Session

There are many benefits to shooting an engagement session. First and foremost, it allows the photographer to get to know his or her clients better before the big day. This can help ease stress and nerves when it comes to actually shooting on the day of the wedding. The couple will get to see how you work as an artist, and get to know your style. The couple will also get to see the flow of a shoot during an engagement session, and that can take away some of the pressure that may be caused from getting professional pictures taken. Some people get tense about getting their picture taken—or hate it—so an engagement session can ease them into it. It is a win-win situation.

Another great advantage to doing an engagement shoot is that the bride can try out a hair and makeup artist. Normally a bride wants to do a test run of hair and makeup before the wedding day, so an engagement shoot could be a perfect time. Sometimes, after I meet a couple and book an engagement shoot with them, the bride will ask for a referral for a hair or makeup artist. I give her my recommendation and on the day of the engagement shoot, the hair and makeup artists come to my studio (about an hour before the shoot) and do the bride's hair and makeup. This is another good way to build relationships with other vendors—the hair and makeup artist and I will then refer each other. It's a simple way to make engagement sessions painless for the couple—why not kill two birds with one stone? About 90 percent of the time, the bride will book that hair and makeup artist after the engagement shoot.

Couples usually want to submit a picture to a newspaper to be in the wedding announcements. A lot of newspapers have strict guidelines for a photo to be

The *New York Times* Photo Submission Guidelines

One of the most notoriously strict newspapers for wedding photo submissions is the *New York Times*. You can find on the website, www.nytimes.com, a list of instructions on how to submit a photograph. The newspaper specifically asks that the couple be "fairly" close together and that "their eyebrows [be] on the same level." I don't know about anyone else, but I know that if I am taking a picture with someone, the last thing I'm worried about is whether or not his or her eyebrows are level with mine!

The paper also asks that the couple be "neatly" dressed and that the photograph be of professional quality. By this they mean they want a jpeg file and RGB color with a file compression size of nine or more. The paper requires that the photo has no red-eye issues, doesn't have a busy background, and is in focus and sharp. This is a lot to ask of a picture. For a lot of couples, these requirements might as well be written in another language. Most couples do not know the terms and therefore don't really know what the paper is looking for. By using a professional photographer, they don't have to worry about any of that. They would be able to submit a photo that the photographer took during the engagement shoot.

Don't forget to mention these points to a couple upon meeting them. This may sway their decision if they are on the fence about doing an engagement shoot. The couple is looking for anything to help them organize and stress less about the big day and a lot of times they don't know much about planning a wedding. A lot of things are being thrown at them. By offering this service and telling them why you offer it and how it can greatly benefit them, they will more likely be eager to schedule a shoot.

Put yourself in their shoes. You're trying to check things off your to-do list for planning the wedding and you're on a tight budget. You already have to compromise some things to make your wedding day exactly how you want it and now you meet with a photographer who keeps trying to shove different a la carte items onto you and smother you with options.

Slow down. Explain to the couple why engagement shoots are so important and how many uses they can get out of the photographs you will take that day. But don't try to sell your services to them. Imagine how you would feel if you were in their shoes—and maybe you have been. Try to think of a nice, nonintrusive way to talk about engagement shoots. Your couple will be more responsive and more willing to spring for something they know can be of multiple uses to them.

submitted. Because of this, it is easier for a couple to have a professional engagement session, where the photographer can shoot a few shots specifically following newspaper guidelines, and then the couple can submit one of those rather than trying to find one that they already have.

To seal the deal, you can mention that the couple can use their engagement session photographs for "save the date" cards to send to their guests, or even to make stamps for their wedding invitations. They can also use the engagement photographs to make a guest sign-in poster or book for their wedding. Add this to the wedding package if the couple likes the idea. The sign-in can be done as a poster, with an 8 x 10-inch black-and-white photo printed on a large, white foam-core poster board. Couples can leave the poster and a bunch of markers where guests walk in, so they can sign it as they arrive. Another option is to make a sign-in book with a selection of photos and other pages left blank for guests to sign.

Another beneficial aspect of shooting engagement sessions is hiring an assistant or a second shooter to help you out. Since engagement sessions are really quick, I usually pay a helper around $100 for the day. I offer engagement shoots to college students who want to learn more about event photography, or to beginner second shooters. They can be a great help, and it is a good way to get to know assistants and second shooters in a low-stress environment. I will usually have the assistant hold lights, umbrellas, or carry things for me. Most of the time, they come in handy as a second pair of hands and it's a really good learning experience for them.

Ideas for an Engagement Session

I like to tell a story with engagement photos and be very artistic, so coming up with the idea is usually the part that takes the longest. Engagement shoots can be really enjoyable, and when you get a really cool idea for one, you look forward to shooting it. Making it fun and exciting makes the couple eager, which makes for a great session.

I love when a couple has an idea for an engagement session. An engagement shoot is more about planning than anything, so when a couple has their own unique idea it can be really easy and fun. Some couples have come up with absolutely amazing ideas. One of my favorite engagement shoots was in a park with a couple that rented a bicycle built for two. The bride-to-be put fresh flowers in a basket and attached it to the front of the bike. The couple was dressed perfectly and the weather was gorgeous. The pictures came out very well, and I still use them today because I like them so much.

Interesting Places for Engagement Shoots

I think the most interesting places for engagement shoots are the places that hold meaning for the couple and that can tell a story. It can be anywhere really; it is all about how you shoot. I have shot in my backyard in front of a large wood pile on a crisp, beautiful fall day. It was perfect. Even though it didn't hold any meaning for the couple and it was a spur-of-the-moment idea, the pictures came out great. The couple was wearing fall colors, the sky was beautiful, there was no wind, and the wood pile created a nice earthy background.

No matter where you live, my advice is to choose a place that you can imagine an editorial for a magazine being shot. That doesn't mean that it has to be glamorous or perfect. Picking the right time and day are big factors as well.

If you live in a desert climate and your clients like the outdoors, choose a place where this would be exemplified in the picture. Sedona, Arizona, with its red rocks and picturesque downtown area, would be a really fun place for a shoot . . . if you live in Arizona. If you live in the Midwest and in a state that blooms in the fall or spring, go out and take pictures highlighting nature. Play up your surroundings. Pick what looks the best for whatever season it is. If it snows and you are shooting a winter wedding, go out and play in the snow. Exciting and fun to shoot, this scenario would have the potential for great pictures.

After getting to know your couple, and depending on what time of year they are getting married, come up with a few fun ideas for engagement shoot locations or ask if they had one in particular. If they want a city setting, bring them to the nearest city. If they want a water setting, find a local lake or pond. Your best bet is to scope out your area and find some "go-to" places for engagement shoots. You should try to aim for shooting in an open space to get clean shots, free of anything distracting and have nice backgrounds. Have a few diverse choices so the couple has something to choose from.

Remember to make engagement shoots as fun as you possibly can because that's what they're all about. If you are excited, the feeling will be contagious. You can squeeze in a few serious shots for the newspaper, but overall, think of the mood as light and entertaining.

If a couple doesn't have a specific idea for an engagement shoot, it's up to you as their photographer to come up with great ideas. Once you meet the couple and get to know them, feed off of this and figure out something they will have fun doing. For another couple planning a New Years Eve wedding, I brought up the idea of doing a really cool engagement shoot with snow in the background, clinking champagne glasses, and a glittering disco ball. The most important part is to make the engagement sessions really, really exciting for both you and the couple.

If you shoot the couple on a picnic by a pond, it looks more editorial. If the pictures turn out really well you can use them for your portfolio or your site. I've also had couples meet me in New York City for their shoot. Depending on the couples' look and whether or not I have time determines whether I will travel to do a shoot like this. I have gone to Brooklyn and shot all day with a couple. A major city is a great place to shoot because of the skyline shots you can get. In the summer I get so busy that I only have time to do a basic shoot, but when I have the time I love to get into engagement shoots and go all out. They're a lot of fun and they can be really silly.

Outdoor Shoot versus Studio Session

Try to offer as many outdoor engagement shoots as you can. Because of where I live and the fact that weather can be unpredictable from November through April, I usually book winter sessions either in my studio or somewhere indoors. I prefer not to shoot indoors if at all possible. Even if it is a cold winter day, I prefer to be outdoors. Where you live and whether the couple prefers an outdoor or indoor shoot will determine which one you will do. Just because I prefer outdoor shoots doesn't mean every couple I book will want to do one. It is important to listen to what the couple wants and cater to that. Whether you do an outdoor or indoor shoot, I have provided a few tips to make them both really fun experiences.

Wardrobe for an Engagement Session

Couples are always very nervous about wardrobe and usually ask me what to wear before an engagement shoot. I did a shoot where we didn't talk beforehand what they should wear, and the groom-to-be showed up in a suit and the bride-to-be showed up in heels. We were shooting in the countryside and it just didn't go at all. I always tell people I want them to look like they do when they go out on a Saturday afternoon, maybe to do errands or something a little nicer. I tell them "nice casual," and that jeans are great. The wedding is when they're going to be dressed up, so

make the engagement shoot fun and very low key. I tell them not to wear red or stripes or anything with a pattern. These make for some very distracting photos. Each engagement session varies, and whether it is a studio session or a photo shoot in a park will determine what the couple should wear. Ask the couple to have two wardrobe changes so the pictures don't all look the same.

How to Shoot an Outdoor Session

When you do outdoor shoots, use natural light and a fill flash if necessary. Most of the time you will not need the fill flash. Try to shoot continuously so you show a lot of action. Outdoor sessions are very organic, so let them just evolve and go with the flow. Have fun with outdoor shoots by using nature and activities that the couple wants to do. If they don't have ideas you can direct them. Set the stage and then tell them to be themselves.

How to Shoot a Studio Session

From a technical point of view, you can shoot in a studio in a couple of different ways. You can bounce light from a reflector from the outside in, and use natural light. I like to do this a lot. Also, have a couple of different light heads that you can put a soft box on, or an umbrella with a flash. I don't like when the light is too even, and suggest that you try something more shadowed. The lighting I use is called photogenic—strobes are connected to my camera and I can have one or two go off at a time. I have two umbrellas for the strobes and two soft boxes. One soft box is big and round, and the other is small, for one person, and is rectangular in shape. Sometimes I'll even just take a light head and use that.

I'm not by the book; I see how light looks on the couples' faces and play around with the people and lighting. And I try to break it up. I'll change the background and the lighting for different shots, so that they all don't look the same.

For studio sessions I recommend using a plain black or gray background. Studio sessions aren't as much fun, but they can produce really beautiful portraits. It is up to you to make them fun. See if you can get the couple laughing, or use a wind machine. If the couple has pets, you can suggest that they bring them along for the shoot.

How to Pose Your Couple

It's a combination of modeling and photographing when you take engagement pictures. Because I modeled for so many years, I try to incorporate what I know

works into the pictures to pose my clients. I try to make the couple feel at ease, and I actually show them exactly what I want them to do. It's usually comical because I'll be really animated and they end up laughing—and then they do it. By showing them exactly what to do, they get a better idea of what you want and what you're picturing in your head. It is automatic pilot once I start shooting. There are certain positions that I know work, and I use those.

For studio sessions I pose the couple with the guy sitting and the girl behind him, draping her arms around him and kissing his cheek or whispering in his ear. I like to shoot them laying down and laughing. Studio sessions can be a little harder because space is confined. Play around and get the couple to do different poses so your pictures come out really well, and don't all look the same.

I'm not into posed shots at all. You know, hand on the hip, that kind of stuff. I want the couple to be themselves and look natural. It's all about trial and error, and seeing what works for you as a photographer and what doesn't. Since every couple is different you have to see what works for the couple as well, because not everything will. As a wedding photographer you have to be prepared to deal with different types of people and realize that you can't have a set standard. You just have to go with the flow and try things out. It can't be forced.

How Many Pictures Should You Shoot?

Engagement sessions are quick. If you have the session planned for a shoot in your studio it can take half an hour, and if it is on location it might take an hour to an hour-and-a-half. The planning takes all the time. During a studio session I shoot around 200 pictures, and I show the couple between thirty-six and fifty of them. When on location I usually shoot between 400 and 500 photos and I show them about 120. This is general—it really varies from situation to situation.

Types of Shots to Get During an Engagement Shoot

All the sessions I do are full-length, vertical and horizontal, with really wide shots. I also like landscape shots and walking shots, with the couple coming closer to the camera from a distance, or the other way around. I like pictures of the couple holding hands with the ring in front and the two kissing in the background. I take a lot of shots with the couple looking up and laughing. It's not cheesy and it looks hopeful. I always do kissing shots and pecks on the cheek. I love running shots where he picks her up. I like pictures where I catch them doing something without me telling them

Different Engagement Shot Poses

I often "direct" my couples during engagement shoots but most couples don't mind this and need very little direction in regard to hugging or kissing. I keep my camera on continuous and snap as many images as possible to capture the most unposed moment. These unposed shots usually come out the best and are what the couple prefers because it seems very natural. Here are five engagement session examples for inspiration on how to pose your couple during a shoot:

1. I shot this picture in my studio using natural light. I like it when the couple's faces are very close together (this makes a great shot for the newspaper). If the male is taller (which he is in most cases) I like to pose him behind the girl hugging her or kissing her.

2. This couple came to me with the idea of riding on a bicycle built for two. I chose a park nearby and shot them having fun together and being themselves. I didn't necessarily have to pose them, I just had to shoot. This was shot in a more magazine-editorial style.

3. This image was shot outside my studio, with the couple hugging while sitting and leaning up against a tree. I made the camera focus on the engagement ring and kept the couple very softly focused.

4. This image also was shot outside my studio. Again, I like the way the couple is interacting, and the guy is hugging the girl. I often ask the couple to look away from the camera as well, for variety.

5. We shot this photo on location at a park just as the sun was setting. This couple wanted more of an editorial feel to the images, and I captured them perfectly kissing as the sun went down. If a couple specifically requests something, I try to pose them to get the perfect picture of what they asked for.

what to do. Generally, I want to tell a story with the pictures, so you get a feeling that it's very romantic.

Uploading Your Photos for the Couple to See

I use a site called Pictage to upload all of my photos for the couple and their guests to see. After an engagement session I load the shots into Pictage, call it "Dave and Micelle's Wedding," for example, and make a separate folder that contains the engagement shots. What is nice about uploading both the engagement shots and the wedding shots to Pictage is that when guests log on to see the wedding pictures, they also see that I shot the engagement photos. It is a nice showcase of my work. It is also convenient for both the photographer and the clients to have all pictures on a single site. See more about using Pictage in chapter 11.

Event Cards

Using an engagement shoot photograph, you can create event cards on Pictage, and get them printed for the wedding. An event card is a way to generate business from wedding guests. The cards have a small picture of the couple, their names, the date of their wedding, and the URL to go to in order to see the pictures from the wedding. I usually put the cards at the bar or by the guest sign-in. I also like to keep some on me at all times because people often ask me for one. If the couple didn't book an engagement session, you can use stock pictures like champagne flutes or flowers in their place. When the guests go to the URL, they can register and buy prints. I have noticed a significant difference in print sales since I started handing out event cards so I have them for every wedding.

Rehearsal Dinner

Rehearsal dinners are another a la carte item that is great to offer to clients. They aren't as popular as engagement sessions, but sometimes a couple that doesn't want an engagement session will opt for pictures of their rehearsal dinner instead. I would estimate that I do about two or three dinners a year, tops. Sometimes a wedding can last the whole weekend long: The rehearsal dinner is held on a Friday, the wedding ceremony on Saturday, and a brunch on Sunday. When I've done weekends like this I have had to get a hotel room (like all the guests), and stay to shoot all three days. I'm there from start to finish.

Event Card Samples

To view and order images of Robyn & Attila's wedding: www.pictage.com

Rehearsal dinners are great because you really get to know who the key players are in the family and bridal party. You already have bonded with them, so when you arrive on Saturday they're not as nervous. This is another great way to get to know your clients and their families before the big day. I really recommend offering rehearsal dinner shoots because they're like a miniwedding that happens before the real wedding. Like the engagement sessions, it can be something you can throw in a package to seal the deal.

Location

Usually rehearsal dinners are held in a private room at a restaurant. Sometimes they are held at other venues with private rooms. Usually they are very upscale and some-what formal. Like I said before, a rehearsal dinner is like a miniwedding. The dinner will have place settings, flower arrangements, and sometimes a program if there are going to be speeches. I've even shot a rehearsal dinner that was held in Cape Cod right on the beach—I remember that it was a lobster dinner and it was absolutely perfect for pictures. When you get an opportunity like that, you really can't turn it down because the pictures can be used for your portfolio or website.

How to Shoot a Rehearsal Dinner

Get to the dinner early to do still lifes of the venue and detail shots. Take pictures of the tables, name cards, flower arrangements, decorations, and so on. Shoot it exactly like you would shoot a wedding. Then, during the cocktail hour, shoot the guests interacting with each other. Try to float around while people are talking, then go up and ask them to look at you and take a picture. Everyone is usually at ease, and you make everyone feel comfortable with you. I usually use two lenses: a wide-angle lens and a telephoto lens to get tight shots, like when guests make speeches or to get expressions. I usually only stay for the first half of the dinner; I typically leave after the toasts.

I usually shoot a couple of hundred shots and edit that down to between 100 and 150 select photos. I upload these pictures to Pictage as well. I make a separate folder and name it "Rehearsal Dinner," so when I give out event cards at the wedding and guests log on to the site, they can see these pictures as well. If a couple doesn't do an engagement shoot, I use a photo from their rehearsal dinner for their event card on their wedding day.

Pre-Wedding Day Preparation

About six weeks before a wedding is when you really need to start planning for the big day. There are many different aspects that you need to go over in order to be fully prepared to shoot a wedding. Six weeks seems like a long time but I recommend using the timeline I've provided as a guideline and not to leave things for the last minute. In the past I have made the mistake of forgetting to book a second shooter, and days before the wedding I had to frantically call every second shooter I have on file hoping that one of them could help me out. You never want to put yourself in that position—it is the worst feeling in the world. I use this timeline for all the weddings I book to keep myself on track. Once you start booking multiple weddings in a weekend, names and dates can get confusing and things can get hectic.

Six Weeks before the Wedding

If you are going to have second shooters, try to book them about six weeks in advance, at least. If you have not met them before, contact them to get to know them and find out about their shooting style. Ideally, you should meet a second shooter prior to the wedding, even if it is just one meeting. If you have used the shooter before for another event, contact him or her to see about availability, and if he or she would be interested in shooting a wedding with you. I will pay usually anywhere between $250 and $350 for a wedding, on the second shooter's skill level. Second shooters are a nice safety measure and make the couple feel secure. Sometimes a couple will request to have a second shooter in their contract. If the couple does not request one, decide if you need to hire a second shooter based on how many guests will be attending the wedding and how many locations you will need to be at during one time.

Second Shooters

I only hire second shooters who have all of their own equipment and their own transportation. Sometimes I will drive with the second shooter, but they need to have their own transportation if we drive separately. I e-mail the second shooter a couple of days before the wedding with the itinerary, and where he or she is supposed to go. I go over all the details of where I want them so they know where to go and when. I usually don't talk to them or see them until after the speeches during the reception.

Again, the biggest thing you want to look for when hiring a second shooter is common sense. Since the second shooter is in one place and I am somewhere else, he or she can't ask me any questions and needs to show initiative to know where to go and what to do. You need to hire a second shooter that you can trust to go off by him- or herself and shoot and get decent shots. You also need to give second shooters a detailed itinerary so they know exactly where they need to go and the time they need to be there.

I have made the mistake of not having great communication with a second shooter before a wedding and it ended up being disastrous. A few years ago I was shooting a wedding and had hired a second shooter who I had worked with before and thought was great. We met up right before the wedding ceremony started and he asked what to do. I told him to go straight to where the reception was being held after the wedding and get all the detail shots before everyone got there. I remember saying, "Don't worry about me, I'll get a ride there." I had one camera and my fanny pack, he left with everything else. So if I needed something out of a bag, it was gone. Luckily I had some equipment on me in my fanny pack so I was able to manage. I kept looking for him during the ceremony, but he was nowhere to be found. This is why I carry a fanny pack with me at all times, with extra batteries and media cards inside. If I had not had that fanny pack, I don't know what I would have done.

I was livid. By the time the ceremony was over and I got to the reception site, I had to start shooting and didn't even have time to talk to him. The worst thing was that we drove to the wedding together and I had to drive back with him after the wedding was over. If that had not been the case, I would have told him to go home and not bother shooting the reception with me.

Being on the same page as a second shooter is imperative. Being able to trust someone, be confident in his or her skills, and be sure that he or she can take on a lot of responsibility is a lot to ask for. That's why it is extremely important to be thorough when you hire a second shooter for a wedding. You have to be absolutely sure that the shooter can handle the pressure and can get all the shots needed.

It is also crucial to send second shooters a detailed itinerary before the wedding, so they can look it over, print it, and bring it with them so they know exactly what to do. Another thing I like to go over with the second shooter before the wedding is that he or she needs to follow my rules and be respectful. A second shooter represents you as the photographer so you need to make sure you choose one that will do the job successfully.

When I put all the wedding information details into my calendar on my computer I put the second shooter's name down too. My entire calendar goes straight to my iPhone so I can stay organized on the go. Because couples will book a photographer more than a year in advance, it is important when you first book a wedding to put all of these reminders into your calendar from the start. Put all the important information (e.g., the couple's names and numbers, the venue, the venue address, time of the wedding, the second shooter's name and number, how many guests) you will need in the calendar so that it is all in one location and easy to find.

A Week before the Wedding

On the Monday before the wedding I call the bride. I call on Monday because I have checked the ten-day weather forecast so we can go over the weather predictions and discuss different situations that could possibly happen. I also let her know that I'm excited for the wedding and to see if she needs anything before the big day. Reaching out to the bride is helpful because she's stressed out and a call is an easy way to put her mind at ease for at least one part of her wedding.

Sometimes a bride might call you, and sometimes you won't ever hear from her because she's so busy. Always try to call first so you are on top of things. You should put this call on your calendar when the couple books their wedding. Even though it's the last thing on your mind, remind yourself to call her.

I usually call the bride, not the groom, because it's her day. I know it's sexist but the guy is typically more laid back. You can call the mother of the bride if she's really involved, but it is best if you deal directly with the bride.

The Day before the Wedding

The night before the wedding, I start charging all of my batteries. I usually bring twenty-five to forty-five AA rechargeable batteries, and they all need to be charged. I also charge all of my camera batteries. I have a system for this that may be helpful to you. I take out all of my batteries and put them on a tray, and as I charge them I move them to another location. That way I know which ones are charged.

I also pack my fanny pack the night before:

- Two cases of media cards
- Extra batteries
- Event cards
- Business cards
- Gum

I put in anything I might need if I don't have my bag with me. I always have a point-and-shoot camera packed, if all else fails. One time my flash wouldn't work during the first dance. It was a fluke, and luckily I had my point-and-shoot. If I hadn't had this I would have lost one of the money shots.

Developing a Ritual for Media Cards

I have a system that I use to prepare my media cards on the day before a wedding. I have twenty-four two-gig media cards. I have six cases and each holds four media cards. The day before the wedding I clear them all and put them, label side up, in a case. Each media card in each box is labeled 1, 2, 3, and 4. When I shoot on a media card, I flip it over when I return it to the case so I know I already shot it, and I go to the next number in the sequence. Each case is numbered as well. I start the day with card case 1, media card 1, and go from there. It's so important to have a system because changing cards is repetitive and this eliminates the chance that you'll shoot over a card. (Find out more about media cards in chapter 11.)

In addition, I pack my camera bags. I have two camera bags; I've tried different ways to pack them, but this seems to work the best. I have one camera bag that's about 2 feet by 1 foot in size. In this I put:

- Two camera bodies
- Two or three lenses
- One or two flashes

I have a smaller bag for extra stuff. I've consolidated it over the years to be smaller. I used to carry a big huge bag, but it was such a pain lugging it everywhere. If you can hold everything you need in a backpack, it's a lot easier. In this bag I might have extra lenses, extra flashes, a lot of extra batteries (both rechargeable and regular), anything I might need a lot of.

After I've packed my bags, I pack all the equipment, reflectors, and ladders. I also make sure my car has a full tank of gas. I print out all of the maps I need for the next day, and staple them together in order of when I will need them. Even though I have a GPS unit, I still print out maps, just in case the GPS doesn't work for whatever reason. One time I went to a town in New York that had three streets with the same name, and the GPS kept bringing me to the wrong one. Since I had the maps printed out I was able to look at those and figure out which street I needed to be on. I also pack a cooler with a couple of water bottles, fresh fruit, and energy bars. In the summer it can get hot and you'll get thirsty. A wedding is an all-day affair and you'll be running around, so pack things that are quick to eat and filling.

I also print the top page of the contract, with all of the numbers and contact information I need, as well as the shot list. I fold these and put them in my fanny pack. I also ask the bride if there's an itinerary, and print that out as well. It's nice to know exactly what time things are happening during the wedding so you know where to be and when (the cake being cut, speeches, etc.). Send this to the second shooter too.

I also figure out what I'm going to wear the next day. I always wear black. Most of the time I'll wear a black suit, but sometimes in the summer I'll wear a black dress or long black shorts. I always make sure I look professional, and so does my second shooter. I also always slick back my hair because I can't stand it in my face. I have a collection of sneakers I wear to weddings. They're colorful and also comfortable. I've made the mistake of wearing stylish shoes rather than shoes with support, and I've always regretted it. At the end of the day I'd come home to blisters and sore feet. It

How to Clean a Lens the Correct Way

Chances are, if you are frequently using your camera and putting it in and out of your bag, the lens will get pretty dusty and dirty after a few uses. It is important to clean your lens the correct way after every few uses to make sure it is crystal clear. Cleaning your lens the wrong way can make the dirt you are trying to remove act as sandpaper, damaging your lens—which can be expensive to fix. It is so important to learn the right way to clean a lens, especially because it is so simple.

In a pinch it's fine to use your shirt—for example, you're getting ready to shoot the bride walking down the aisle and you notice your lens has a smudge. But if you have the time, especially the night before a wedding, cleaning your lens the right way is a good habit to get into. Here are three steps to correctly clean your lens.

1. Begin by blowing as much dirt away as you can. It is recommended to use a squeeze bulb, which you can find at dealnay.com (http://dealnay .com/1006528/polaroid-super-blower-with-hi-perfomance-silicon-squeeze-bulb.html). A squeeze bulb is a lot less damaging to your camera lens than, say, high-pressured air, which can shatter your lens. If you don't have a squeeze bulb or you're on a job, using your mouth to blow air on your camera can be a last resort.
2. Next, use a lens cloth or lens wipe to wipe in circles, starting at the middle of your lens. You can either use a disposable lens wipe or buy a microfiber lens cloth, which can last for a long time. I recommend using a cloth that is specifically designed for cameras or lenses, like the one available at Simply Good Stuff (www.simplygoodstuff.com/microfiber_lens-cloths.htm). It is washable so you can get multiple uses out of it, which is really great.
3. The last thing you need to do, if there are spots that won't go away after following the first two steps, is use a cleaning solution. Look for an alcohol-based solution that dries quickly, and remember to never apply the solution right on the lens because it can seep through and go inside your camera.

Some companies make kits that have all the supplies you need to follow these steps and keep a clean lens. Canon makes a great kit, which you can find on Amazon (www.amazon.com). It comes with a soft retractable brush, squeeze bulb, lens cleaning fluid, microfiber cloth, and lens tissues, which all fit neatly inside a plastic case that you can easily store in a pocket or camera bag. I recommend having something like this, or making your own kit to take with you on shoots—or have available at all times. If you have a kit ready to use and easily accessible, you will be less tempted to use your shirt!

can also be distracting if you're worrying about how much your feet hurt or wondering where you can find a bandage to put over forming blisters. Make sure you wear shoes that are professional but also functional. You have to remember that you're going to be running around all day and be on your feet for ten-plus hours. I highly recommend wearing sneakers—your feet will thank you!

On the night before the wedding, do not to go out or stay out late. Weddings are extremely exhausting and as the photographer you're constantly going to be on the move. It is important to get a lot of rest the night before to be prepared for that kind of strenuous work. It is a good idea to have all your equipment packed and ready to go the night before so in the morning you are not rushing around and putting everything together.

The Morning of the Wedding

The morning of the wedding I double-check to make sure I have everything. Try to be a few minutes early—it is not wise to be rushing on the day of the wedding. It adds to the stress level. Allow yourself extra time in case you get lost or stuck in traffic. If you are late, always call the bride's cell phone; if she is getting ready at a hotel, call the hotel and ask to be put through to her room. I hate doing this because she's already stressed enough. That's why I overprepare.

Why It Pays to Have a Reliable Vehicle

I've had my car break down on the highway on the way to a wedding before. I had to call AAA, and then call a cab to take me to a rent-a-car place, which was an expensive cost that I wasn't expecting to pay that day. I allowed a lot of time to get to the wedding that day because I knew there was going to be a storm, so thankfully I still got to the wedding on time. The bad part was that I had to load all of my gear into a taxi, then go twenty miles out of the way to rent a car, move all my gear from the taxi in a rental car, and then drive the twenty miles back to where I broke down and continue on to where the wedding was being held. I learned my lesson, and I traded in my used Mercedes that was always breaking down for a used Honda that is said to be very reliable, because I told myself that was never going to happen again. Clients have asked me what kind of car I have. They want to make sure I have all-wheel drive for the winter, or at least have a reliable car so they know I'm going to show up to the wedding.

Make sure you have some sort of roadside service, like AAA, that you can call if your car breaks down or you get a flat tire. You can visit www.aaa.com, where you can do a search for your local AAA club. AAA not only gives you peace of mind about your car, but members receive many different discounts, ranging from movie theater tickets to prescriptions.

Another way to find roadside service is by asking your automobile insurance agency if that is something they offer. Insurance companies provide roadside assistance (e.g., Allstate has what it calls the Allstate Motor Club). It might be beneficial to switch insurance companies to find one that offers this service. It is an added cost, but having the benefit really saved me in the situation I mentioned above, and I'm really glad I have it.

Checklist

I've had situations where I have forgotten things. I try to avoid this at all costs, but sometimes I'm in a hurry and things slip my mind. One time I forgot all of my media cards. Halfway to the wedding I realized it, and had to turn around and go back home. Another time, on my way to a shoot, I realized I forgot my AA batteries and had no extras. I had to go to Walgreens and buy a ton of batteries. Another time I forgot all of my camera batteries. Fortunately, my friend lived twenty minutes from where I was; he had the same camera, and he drove to the wedding and brought me camera batteries. It was a nightmare. I got all the way to the wedding, and I was unpacking, getting ready to shoot, when I realized I didn't have the camera batteries! If you're going fast, you are bound to forget something.

To avoid this, make a checklist for each time you pack your bags before an event, so you don't forget anything. Do the checklist the night before, so you aren't rushed.

See the preparation checklist on the next page for a list of everything you need to pack before the wedding.

Preparation Checklist

- ❏ Two SLR camera bodies
- ❏ Two speed lights
- ❏ An assortment of five lenses
- ❏ Battery pack(s)
- ❏ Tons of rechargeable AA batteries
- ❏ Battery chargers for cameras and AA batteries
- ❏ Media cards
- ❏ Reflector
- ❏ Flash diffuser
- ❏ Tripod
- ❏ Ladder
- ❏ Business cards
- ❏ Event cards
- ❏ Point-and-shoot camera
- ❏ Energy bars
- ❏ Water
- ❏ Breath mints
- ❏ Cell phone
- ❏ Tissue
- ❏ Fanny pack
- ❏ GPS unit
- ❏ Printed maps and directions
- ❏ Numbers of the bride and groom, and of the hotel where they will be getting ready
- ❏ Second shooter's number
- ❏ Guest sign-in (if they added it to the package)
- ❏ Shot list (if they gave me specific shots they want taken)
- ❏ Gas in the tank

Shooting the Wedding Day

The day of a wedding can be stressful for any professional photographer. Get out all your nerves before you arrive to shoot because once you get there, you'll be the one calming everyone else down. Just kidding . . . But seriously, once you wake up, it's go time.

At the start of the day you need to get your mind in the "game," and mentally prepare yourself for the next ten or so hours. I like to wake up early to meditate and pray before I start my day. I find it helpful to start my day slowly and calmly. I have overslept and rushed around the morning of a wedding, and all it does is add to my stress level. When that happens, everything that follows tends to feel stressful, which is why I like to wake up early.

Make sure you take the time to make yourself presentable because, after all, you are representing your business and how people perceive you will reflect on your business. Since I try to have absolutely everything packed and ready to go the night before, there isn't much left to do in the morning but relax. I like to sit down, read the paper, and eat a filling breakfast, because oftentimes I don't get a chance to eat until dinner at the reception later that night. I like my mornings to be as relaxed as possible because I know that the rest of my day will be very busy.

Sample Wedding Itinerary

It is important to have the wedding itinerary on you at all times. It tells you where you and your second shooter need to be at all times during the day. This is a sample itinerary of a wedding:

- 1:00 p.m. Bride and bridesmaids arrive at salon for hair and makeup
- 2:00 p.m. Caterer arrives at reception venue

- 2:30 p.m. Bride and attendants finish at salon, leave for church
- 3:00 p.m. Bride and attendants arrive at church to get ready; Lighting tech arrives at reception venue and sets up
- 3:15 p.m. Photographer arrives at church, photographs bride and attendants getting ready
- 3:30 p.m. Wedding cake is delivered to reception venue; Flowers arrive at reception venue
- 3:45 p.m. Wedding planner arrives at venue to set up centerpieces and decorate
- 4:00 p.m. Personal flowers (bouquet, corsages, boutonnieres) arrive at church; Groom and groomsmen arrive at church
- 4:15 p.m. Photos of groom, groomsmen getting ready
- 4:20 p.m. Reception venue staff moves furniture into reception area, wedding planner sets up lounge seating area near bar
- 4:30 p.m. Band arrives to set up at reception venue
- 5:30 p.m. First guest arrives at church
- 6:00 p.m. Ceremony begins
- 6:30 p.m. Ceremony ends
- 6:45 p.m. Sign the wedding license, photos with officiant, photos of bride and groom, group photos of entire wedding party; First guests arrive at reception venue for cocktail hour
- 7:00 p.m. Transportation for bride and groom arrives at the church
- 7:15 p.m. Move outside to garden behind church for photos with bride and groom
- 7:30 p.m. Bridal party leaves for the reception venue; Lighting tech tweaks lights in reception venue
- 7:45 p.m. Bridal party arrives at reception
- 7:50 p.m. Guests are asked to move to the reception room
- 8:00 p.m. Bridal party enters the reception (or are announced)
- 8:05 p.m. First dance as newlyweds, followed by a very short dance set
- 8:15 p.m. Toasts
- 8:20 p.m. Dinner
- 9:10 p.m. Father-daughter dance, groom dances with mother, followed by a short dance set
- 9:40 p.m. The cake-cutting ceremony, followed by dancing

- 9:55 p.m. The bouquet toss, followed by the garter toss, then more dancing
- 10:30 p.m. Music winds down, bar starts to close
- 11:00 p.m. Reception ends, guests gather out front for the send-off
- 11:10 p.m. Newlyweds leave the reception
- 11:20 p.m. Newlyweds arrive at wedding night hotel

Shooting the Bride and Bridesmaids Getting Ready

I show up two hours prior to the ceremony to meet up with the bride and bridal party. The four most common places I meet the bridal party are at her mom's house, at her house, at a hotel, or in the bridal room at the wedding venue. I walk in with all my gear and introduce myself to every single person. I like to get acquainted with everyone and tell them I'm going to be taking their pictures, both candids and posed shots. I look at my surroundings, inside and outside. I usually start with the bouquet and any detail shots I want to take. I pretend I'm shooting an eight-page fashion story. To have eight killer shots is hard.

I shoot with two cameras. The first has a 24-70 mm lens with a flash and a flash diffuser. I take all flash shots with this camera, which is more of the candid stuff in the house. The other camera I shoot with has an 85 mm lens, with which I shoot in natural light. I can take the flash off the 24-70 and use the macro lens to get tight shots of the bouquet. I can shoot from two inches away, and it will be crystal clear. If there are boutonnieres I'll do those as well. I always ask to see the girl's dress. I very often move the dress to a backlit window and set up the flowers with the dress. I want to shoot a story, and always keep in mind I'm pretending to shoot an editorial spread.

Actually, for each one of these sections, I pretend that I am shooting an eight-page spread. It forces me to "pull a rabbit out of my hat," because it's not always beautiful. You have to rearrange things to make them work. I try to find a corner or a clear space so at least the background is good. I always ask people if I can move things around to get a better shot.

After the still lifes, I start with whichever bridesmaid is ready. I tell her, "Let's go shoot *Modern Bride* or a really great Facebook profile picture." I absolutely love shooting in a doorway. I usually do headshots with each of the bridesmaids. Then I shoot the mother of the bride, the father of the bride, and any siblings. I do everyone's "beauty shot," and once everyone is ready I do a whole spread with all of

Bride and Bridesmaid Shot Checklist

This is a list of the types of shots you need to get during this part of the day. It is not a list of shots you need to get and that is it. Try to go with the flow and if you have an idea or something comes up, shoot as much as you can and don't worry about whether it is on the list or not. A lot of wedding photography is about being spontaneous and thinking quickly on the spot.

Bride Shot List

- ❏ Bride's dress hanging up
- ❏ Jewelry before it goes on
- ❏ Shoes before they go on
- ❏ Garters before they go on
- ❏ Shots of something borrowed, something blue, and something new
- ❏ Hand bag
- ❏ Bride getting her makeup and hair done (tight beauty shots for this)
- ❏ Bride holding her wedding dress before she puts it on
- ❏ Bride getting into her wedding dress with help from mom or sister(s)
- ❏ Bride with mother and bridesmaids once she is dressed
- ❏ Beauty shots of bride (tight beauty shots work best)
- ❏ Bride with bridal bouquet
- ❏ Bride with mother
- ❏ Bride with father
- ❏ Bride with mother and father
- ❏ Bride with siblings
- ❏ Bride with maid of honor
- ❏ Bride with bridesmaids

- ❏ Bride full-length shot showing off her dress (I prefer to do this outdoors for the background)
- ❏ Bride walking to car
- ❏ Bride beauty shot once inside car

Bridesmaid Shot List

- ❏ Girls getting ready and hanging out in street clothes
- ❏ Each girl getting her makeup and hair done
- ❏ Beauty shots of each bridesmaid once she is dressed and with her bouquet
- ❏ Fun *Vanity Fair* cover-type shots of all the bridesmaids together
- ❏ Shots of the girls together with their bouquets outdoors
- ❏ Shots of the girls indoors
- ❏ Shots of bridesmaids with bride

them. I like to think of it as a *Vanity Fair* shoot, where a fold is going to open up. I try to make the pictures more fun than of everyone just standing there.

Finally, I move on to the bride, because she usually gets ready last. I like to do the bride getting ready. I photograph the bridesmaids in the background—I always stage this shot to feel the energy. I also take shots of the bride adjusting her veil. Try to get private shots between mother and daughter or father and daughter. I do a lot of beauty shots of the bride, because her makeup is perfect. If there are presents, glasses of champagne, an invitation, include all these detail shots to try to capture the essence of getting ready as a whole.

Shooting the Groom and Groomsmen Getting Ready

The second shooter typically will meet up with the groom and groomsmen, because they will be at a separate location. Unless the wedding is small and the groom's party is across the hall, I'll tell my second shooter to do the groom and his men while I do the bride and the bridal party. I like to have shots of the boutonnieres and cuff links, shots of the guys laughing, headshots, etc.

Groom and Groomsmen Shot Checklist

The best advice I can give you for these types of getting-ready shots is to have fun with them. Be creative and silly, and have your second shooter do the same. Don't be afraid to suggest things to the men because they aren't sure what you want them to do. Improvise as you go along.

Groom Shot List

- ❏ The tux hanging up
- ❏ Cuff links
- ❏ Rings
- ❏ Boutonniere
- ❏ Pinning boutonniere on groom (either by mother or best man)
- ❏ Portraits before the tux goes on, while he is still in street clothes
- ❏ Getting dressed (e.g., shoot the adjustment of a tie, fixing a cuff link)
- ❏ Portraits of groom in his tux
- ❏ Groom with mother
- ❏ Groom with father
- ❏ Groom with mother and father
- ❏ Groom with siblings
- ❏ Groom with groomsmen indoors
- ❏ Groom with groomsmen outdoors; shoot them walking toward camera
- ❏ Groom getting into car going to the church (if second shooter is riding with the guys, get shots of them in the car or bus having fun)

Groomsmen Shot List

- ❏ Shot of guys hanging out (make these shots more candid)
- ❏ Guys getting dressed in their tuxes

- ❏ Guys adjusting their ties and getting ready
- ❏ Portraits of each groomsman
- ❏ Shots of groomsmen assisting each other with their boutonnieres
- ❏ Portraits of all the groomsmen inside
- ❏ Portraits of all the groomsmen outside
- ❏ Editorial shots of all the guys walking toward camera
- ❏ Best man with groom

Guys don't typically like getting their pictures taken, so find a second shooter who is really outgoing. In the past I've gotten really great shots of the groom and groomsmen playing cards and drinking beer. You want to capture the energy there. As for the detail shots, I like photos of the men adjusting their ties, looking in the mirror, fixing a cuff link, or anything that looks editorial, like it belongs in the magazine. I also have the second shooter do family pictures, because usually the groom's family will be there. The groom and groomsmen typically arrive at the church half an hour before the bride, so I have the second shooter follow them, also capturing guests arriving at the church and anything else going on.

Traveling to the Church

After taking shots of the bridal party, follow them to the car. I always have my bags semipacked at this point, so I can leave quickly. Tell the driver to wait. Even though I have a GPS, it is always nice to just follow behind the car to know where to go. I'm usually the last to leave, and sometimes I'm the one locking up the house where the bride got ready. I have ridden in the limo before, because sometimes logistically it doesn't make sense for me to drive, and I'll keep taking pictures in the car. I have the girls pretend like I'm not there. This is a great opportunity to take candids and capture private moments between family members.

Shooting the Wedding Ceremony

Once you get to the church you need to make sure all of your gear is set. This part goes by so quickly, so have your gear prepared. Change your batteries and your

Ceremony Shot Checklist

These shots are the most important shots that you will take all day. It is extremely important to get, at a minimum, the shots listed below, and it would be better to get more than these. Also, if your couple gave you specific shots they want, get those as well.

Ceremony Shots

- ❏ Shot of groom's parents being seated
- ❏ Shot of groom's grandparents being seated
- ❏ Shot of bride's parents being seated
- ❏ Shot of bride's grandparents being seated
- ❏ Shot of groom
- ❏ Shot of groomsmen
- ❏ Tight shots of guests waiting for the ceremony
- ❏ Tight shots of parents on both sides waiting for the ceremony
- ❏ Shot of each bridesmaid
- ❏ Flower girl coming down the aisle
- ❏ Ring bearer coming down the aisle
- ❏ Shot of the band or solo musician (if there is one)
- ❏ Shot of bride and father (long shot)
- ❏ Multiple shots of bride and father walking down the aisle
- ❏ Shot of father kissing bride/giving away bride
- ❏ Shot of father shaking hands with groom

(Move to the back of the church or place of ceremony. Don't forget to turn off your flash.)

- ❏ Wide shot of ceremony
- ❏ Tight shot of back of bride and groom (or a side view)

(Move to the other side of the ceremony at the front, but very unobtrusively.)

- ❏ Tight shots of bride's expressions during ring exchange

- ❏ Tight shots of groom's expressions during ring exchange

- ❏ Shots of parents/family/friends' expressions during ring exchange (if you have time)

(Move to the back of the ceremony again.)

- ❏ Wide shot of ring exchange

(Return to the front right side.)

- ❏ Tight shots of bride's expressions

- ❏ Tight shots of parents' and guests' expressions

- ❏ Tight shots of maid of honor's expressions

- ❏ Tight shots of groom's expressions

- ❏ Tight shots of best man's expressions

(Return to the back of the ceremony venue again.)

- ❏ Wide shot of ceremony (maybe with a different lens)

- ❏ Tight shot of ceremony program

- ❏ Tight shots of ceremony flowers

(Move in down the aisle closer to bride and groom.)

- ❏ Wide shot of the couple being pronounced husband and wife

- ❏ The "you may now kiss the bride" shot (shoot with flash)

- ❏ Shots of couple after kiss, smiling

- ❏ Shot of couple turning to guests as husband and wife

- ❏ Shots of couple walking back down aisle (You are walking backwards. Slow the pace and motion with your hand for the bride and groom to slow down as well.)

- ❏ Shot of bride and groom kissing at end of aisle (ask them to do this)

- ❏ Shot of bride and groom leaving church or ceremony (a back shot)

media cards because you won't have time once the ceremony begins. I've made the mistake of not doing this and my camera has died halfway through the ceremony. It really sucks if you run out of media and the bride starts coming down the aisle. That's why I carry a fanny pack—because it's all right there. I know my media cards are flipped right, which is why it is smart to come up with some kind of system for keeping your media cards organized.

You, as the main photographer, go to the front of the church where the priest, pastor, or officiant is. I shoot with two cameras during the ceremony. Other photographers don't usually do this but I prefer to: It's total muscle-building. I use a 7200mm image stabilizer lens that I crank up the ISOs on. (ISO is the International Organization for Standardization and measures the sensitivity of the light sensor, the lower the number the less sensitive your camera is to light, and higher ISOs are generally used in darker rooms to get a faster shutter speed.) I don't like shooting people that look like they have a flash on them because they don't look natural. I do shoot with a flash with my other camera because sometimes I have to. I tell my second shooter to go in the hall where the bridal party is asked to wait before walking down the aisle. I have him or her shooting the people come in, and if there's an upstairs, he or she will sometimes go upstairs.

First the parents come down the aisle, and then the bridal party. These are mandatory shots, so you can't miss them. Then once the bride is about to come down the aisle, people start to get in the way. This happens all the time. The guests go out in the aisle with their own cameras, trying to get a good shot. There are hands and cameras in these pictures all the time. Sometimes I have to go and tell them to please move. If there's a video guy I tell him to go on the left side so we stay out of each other's way.

Then once the father "gives" away the bride, it gets really tight up at the front with the bridal party. Go back around and take wide shots from the back of the church, to get everything in one shot. After the bridal party has come down the aisle you can rarely use a flash, so you have to have a really good camera that can shoot in low light. Go around to the other side and focus on the bride, her expressions, and her family. By this time the second shooter has come down from upstairs or come into the church from the hall, and he or she should focus on the groom, his expressions, and his family. If it's a full mass, there is time to look for a program and do a still life of it. If there are flowers on the pews, shoot them with the bride and groom fuzzy in the background.

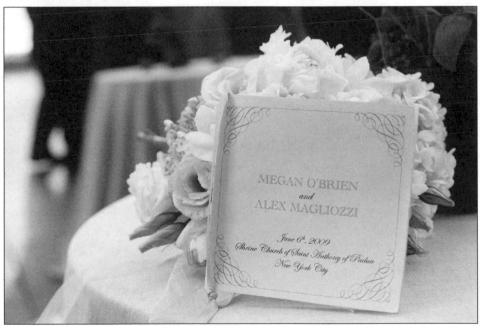

If I have time, I'll go upstairs with a fisheye lens and do a wide shot of everything going on, so viewers can really get the feel of it. Look at the ceremony program because then you'll know where to be when things happen. If you need to be close to the podium with a long lens and no flash, you'll know exactly when you need to be there. Everything happens quickly, so you have to be aware of what's going on at all times.

As the bride and groom exchange rings and kiss, you need to be in position to get these shots. Then you need to get a shot of the couple walking back down the aisle as husband and wife. They usually walk down so quickly you may have to have them stop and smile or kiss to get a good shot. Remember, you are in control. You have to tell them to stop because you don't want to rush and be out of focus or not have adequate light. This is a money shot, so you need to do whatever you can to get it right.

Shooting the Receiving Line

The receiving line is very tricky to shoot. People are facing each other so you either get the back of someone's head or barely a profile. Use the 7200 lens and natural light. Do tight head shots (I like to get faces and expressions). It's kind of like shooting ducks in a barrel. Try to find a face, or two people hugging, and boom—shoot it; you have to be ready. The 7200 is a heavy lens, so you have to be strong. If the line is inside, you can use a flash. If you step back far enough, it's cool to get the church and the whole crowd into one shot.

Shooting the Bridesmaids and Groomsmen

Try to shoot the bridal party first, especially if there are children involved. They are usually really hyper and want to go get drinks, so try to get them done quickly. First, I usually do the typical shot with the bridesmaids on one side and the groomsmen on the other because the parents like that. The couple usually doesn't care. I do a lot of shots of the bridesmaids and groomsmen walking towards the camera. It's a signature shot. Shoot the groomsmen jumping, so they are all in the air, or the bridesmaids all striking a funny pose. By this time they've loosened up and gotten used to me, so I try to make these pictures really fun. Do separate shots of the groom with his men, then the girls with the bride, and then the groomsmen picking up the bride—things like that. It depends on the couple, but I like to have fun.

Shooting Family Portraits

After the bridal party, take all the family portraits. Do the bride's family first. Put the bride and groom in the center with the parents on each side. I like to have the men on the end—I always call them my bookends. After that, add siblings to the pictures. Take pictures of the bride and groom with all of their siblings. Then break it up and do just bride and her siblings, and then the groom and his siblings. I have the groom's family waiting, so they can get done right away, and I use the same format with the bride's family. It goes by quickly because everyone gets the hang of it.

Shooting Bride and Groom Portraits

Go over this part of the shot list in advance. I shoot these portraits last, typically. They could be in the church, outside of the church, or at a park on the way to the reception. Set this up in advance. Move the couple around as much as you can to get different backgrounds; again, try to have this set up in advance so you know where you want them to stand. Use a fill flash if it is super sunny and there are no shadows. It's not really what I like to do, but you always have to be ready. I try to find shade, as I don't like shooting in direct sun. Bring reflectors. Look for clean backgrounds. I like

The Thank-You Card Shot

Shooting a "thank-you card" shot can be arranged ahead of time if the couple wants. Thank-you cards can be an a la carte item that couples add to their package. This is usually worked out way before the ceremony day. It is part of the shot list that each couple makes prior to shooting the wedding. Usually, when I meet a couple for portraits on the wedding day, I shoot this shot. Sometimes I'll bring along a thank you sign that they will hold, or I will use a picture from the portrait shoot to put on the card. It is a good idea to put your logo on the back or bottom corner of the card, to further expose your business. Thank-you cards are great to offer because it is extremely convenient for a couple to order them from you. If the couple decides to use the image as a thank-you card, they can order it via Pictage and I am able to make money on it. It is a nice sell factor for some clients and it feels very personalized.

to have the couple looking off, or smiling and holding hands. I try to spend a majority of my time shooting portraits with the bride and groom.

Shooting the Cocktail Party

Half the time the cocktail party is held a while after the ceremony, and the other half I miss the first thirty minutes because I am doing the portraits. If the latter is the case, have the second shooter go straight to the reception site and start shooting a lot of still lifes. Ask the second shooter to shoot the room. The candles are lit, and this is the best the room is going to look.

During the cocktail hour, go around to each person and say, "Hey, do you mind if I take a picture?" I like to shoot in twos, threes, and fours. You can start at one end of the room and the second shooter at the other, and you'll eventually meet in the middle. If there is time, go around and do all the still lifes. I think of them each as individual details. If you have time, use a 7200 lens and go around taking tight shots. Try to be really incognito. I try to go around like a spy, and take as many candids as I can. I make it my goal during cocktail hour to get every single person. I also like to get a wide shot of the whole room during this hour.

Shooting the Reception

For the reception, I like to be about twenty-five to thirty feet away from the door where the bridal party will be entering the room. Have the second shooter be about forty-five feet away. This produces different perspectives of the same shot. Have the second shooter use a flash, while you just crank up the ISOs (if it is darker in the room) to get the shot.

For the first dance I use two cameras. I use the 7200 lens for natural light and the 24-70 mm flash. Shoot nonstop and move as the bridal party moves. Do the opposite shot of the crowd watching. After that, move in and do tight shots of the bride and groom's expressions. Be completely natural—don't go up and say, "Hey, can you look at me?" I never interrupt at this time.

For the first dance, make sure the second shooter is out of the way so he or she isn't in all of the shots. I like to have the second shooter use a long lens and get the expression of the moms and dads during this time.

You can take the main shots for toasts and have the second shooter getting the expressions of all the guests. There is no point in having two people shooting the same thing for the toasts. Having a second shooter is great for these types of

Still Lifes Shot Checklist

My rule of thumb for shooting still lifes is, "Would you want to see that photo in a picture frame?" Shoot as many still lifes as you can, and of anything you can think of. It is always better to have more shots than too few. These types of shots are important to remembering small details of the wedding that the couple or their guests might forget about.

- ❑ Flowers
- ❑ Boutonnieres
- ❑ Wedding dress
- ❑ Tuxes
- ❑ Shoes
- ❑ Jewelry
- ❑ Wedding invitation
- ❑ Ceremony program
- ❑ Interior of reception room
- ❑ Exterior of reception venue
- ❑ Tight shots of tables at the reception
- ❑ Wedding cake
- ❑ Champagne glasses
- ❑ Place settings
- ❑ Exterior of wedding venue
- ❑ Interior of wedding venue
- ❑ Car/limo shots
- ❑ Rings

Second Shooter Shot List

I expect my second shooter to give me at least 250 edited great shots.

- ❑ Follow groom and groomsmen
- ❑ Groomsmen at church or ceremony location, waiting for the bride and bridal party
- ❑ Bride and bridesmaids arriving at ceremony location
- ❑ Balcony shot of ceremony
- ❑ Tight close-ups of groom during entire ceremony
- ❑ Tight shots of groom's parents during ceremony
- ❑ Wide-angle shots of ceremony (but out of the main photographer's way)
- ❑ Shot of bride and groom coming out of church after being married
- ❑ Shots of all guests during cocktail hour (Make each image something you would frame as a 5 x 7. Take horizontal shots. No back or side views of guests, or of guests eating.)
- ❑ Shots of reception room prior to guests' arrival
- ❑ Shots of still lifes: table settings, flowers, and wedding cake
- ❑ Shots of main photographer shooting formal shots (for blog use)
- ❑ Shots of bridal party being introduced at reception (tight shots)
- ❑ Shots of bride and groom's first dance (out of eye sight of main photographer)
- ❑ Shots of guests seated before dinner
- ❑ Table shots of guests
- ❑ Interior room shots on a tripod with no flash
- ❑ Shots of people dancing fast (vertical shots)
- ❑ Shots of people dancing slow (tap the couple on the arm and ask that they look at the camera)
- ❑ Shots of the couple cutting the wedding cake

- ❑ Shots of the flower bouquet being thrown
- ❑ Shots of the garter being thrown

Still Lifes Shot Checklist

- ❑ Flowers
- ❑ Boutonnieres
- ❑ Wedding dress
- ❑ Tuxes
- ❑ Shoes
- ❑ Jewelry
- ❑ Wedding invitation
- ❑ Ceremony program
- ❑ Reception room
- ❑ Tight shots of tables and contents
- ❑ Wedding cake
- ❑ Champagne glasses

situations because you get to shoot both sides—the person making the toast and the crowd's reaction. It is a nice way to remember the speeches.

The dancing shots are very difficult to get. You have to shoot nonstop. With all the slow-dancing shots, take vertical shots. I will go up and ask the dancers to look at me. Even if it's fast, sometimes I have them look at me. Get right into the crowd and be fearless. The real party might be on the dance floor, and you don't want to miss any of that. Try to get into the music; be part of the party. I've even gone back by the band or DJ, because sometimes they have a really good point of view. I even go up on the DJ's speaker to get a really wide shot of the whole dance floor.

For the bouquet toss, try to be in front, where the bride is facing, and have your second shooter shooting the other way, showing the bouquet coming over the bride's head. You definitely need two people doing this. The second shooter gets

the expression of whoever catches the bouquet and I can get the bride's expression regarding who caught the bouquet. Do the same thing with the garter toss.

A lot of times the couple doesn't know what they're supposed to do during the cake cutting, so I tell them. I try to find a good background to make the most of the photos. Sometimes the vendor won't put the cake in a good spot with a great background, so sometimes I have them move it. I get clean shots of them cutting the cake, kissing and holding the knife, and then feeding it to each other.

When the couple is going to exit, it is good to be right in the crowd. Sometimes the couple will change and sometimes they won't. Follow them out to the car and keep shooting nonstop. Have your second shooter taking pictures the other way, of the crowd waving and laughing. I did one wedding where the couple got on a boat and I took pictures of them sailing away. Those made some really great shots. Sometimes wedding guests write JUST MARRIED on the car—it is very traditional and old school. It doesn't happen a lot, but I think it's such a great, classic way to end. I'm always there till the very end, getting shots of the car driving away.

Money Shots

You cannot miss money shots. They are the type of shots that a couple demands from a photographer and that you are expected to shoot (e.g., father and daughter walking down the aisle, the kiss, husband and wife walking back down the aisle). Use the list that you gave to the couple when you booked their wedding and asked them to check off the specific shots that they wanted. Make sure you have this with you so you can check the shots off as you go.

Before the big day, I recommend reviewing the shot list (provided in chapter 7). Sometimes the couple will give you a list of shots that they would like to be taken. Print both of these out and look it over the night before. Also print out the itinerary (see the sample wedding itinerary on page 111), and compare notes. If you think it would help, write the "name" of the shot where it would logically be taken on the itinerary so you know the general time frame that you have to get that shot. This can be helpful, but remember that the itinerary is not exact and is subject to change. Don't rely on it; just use it to mentally prepare the night before.

The biggest piece of advice I can give you regarding money shots is that you need to know what is happening before it happens. You need to be there, in the midst of all the action, getting the shots you need.

11 Editing a Wedding for Client Presentation

Once the wedding is shot, the editing process begins. This process can vary, depending on the wedding size and whether I have other weddings to edit at the same time. It helps to stick to one wedding at a time. I prefer to get the editing process done in one or two sittings that are (mostly) uninterrupted. For this part of your wedding photography business, it really helps to be organized and methodical. There are many different ways that the editing process can go wrong, but having a list and coming up with habits can eliminate problems. For some photographers, the editing process might be their favorite part of the job or their strongest skill.

Developing a Ritual

The most important part of uploading your pictures from media cards to your computer is having a ritual, so that you never lose any files. As stated previously, I have card cases that hold four cards (I use two gig or four gig cards because if something goes wrong, it is a lot easier to lose two gigs than sixteen gigs worth of shots.) When I pack my camera bag to go to a wedding I place all the media cards with the labels facing up. All my media cards are reformatted prior to arriving at the shoot. During the wedding, whenever I fill a card, I put it back into the case with the label side down. Then I take the next media card (facing up) and fill that one. This way I know which cards have been shot and which ones are empty. I might have two or three shoots in a row, so after each shoot it is important to put a sticky note on each card case labeling which shoot the media cards are for. This is a way that works for me. You can try this or come up with your own way.

It is important to have a ritual so you don't shoot on a card that you have already shot that day. It has happened to me before. I have taken a card out,

thinking it was empty—but it wasn't. I've accidentally reformatted it and shot over pictures from the wedding that I needed. That is not good. Unfortunately, there is no way to recover lost photos on a media card. If you shoot over a card, or you accidently clear a card you thought had no new pictures, there is nothing you can do. I can't stress enough how important it is to be organized and develop some kind of practice that helps you remember which cards are shot and which cards are ready to go.

The Editing Process

When you are starting out, you need to have a list of procedures to make the editing process easier, so you don't skip any steps. I have provided such a list in appendix C for easy reference. It is easy to get lost in the editing process and the list will keep you on track. Having a guideline also is helpful to start coming up with your own ritual.

Making Folders

The first thing I do when I get to the studio after a shoot is make a new folder on my external drive called FULL JOBS, with the bride and groom's last name and the date. Full means it contains all the pictures I shoot at the entire wedding. Let's say the couple's last names are Smith and Anderson. The folder title would be "Smith/Anderson wedding full 07/30/11." Once I download all the media cards into the folder on the external drive, I take a look at the images to make sure I downloaded the most important shots. Well . . . they are all important, but I make sure that everything I recall shooting is in the folder. Typically, for a wedding of 150 guests, I shoot about 1,500 images total.

Once I am satisfied with the download of the images, I copy the entire folder onto another external drive. The jobs that I shoot each week are all downloaded off of the media cards and placed in a specifically named folder for each client. On the FULL JOBS external drive, all the jobs that I have not edited stay on the drive in a folder I name TO BE EDITED. This TO BE EDITED folder is the one folder that you cannot lose. On my Mac computer I have a service called Time Machine; Time Machine backs up my TO BE EDITED folder several times a day to another external drive. Once I edit the photos, I'll have other versions in case something happens, but until then the TO BE EDITED folder is all I have, so I need to make sure it's saved in more than one place.

Once the photos are downloaded, I can reformat the media cards and go shoot the next job. I do try to keep the pictures on the media cards until the job is edited

and the pictures are burned on a CD or DVD. If you have enough cards you can do this, but before reformatting the media card for another shoot, make sure you have the files saved on your computer and on an external hard drive. This is critical.

Once I back up the folder, so there are two copies of the photos, I open up everything in Adobe Bridge and start to go through all of the pictures, deleting the ones that I can't use. This is the second part of the process.

Then I go through the shots again and organize all of the photographs in a time frame. It is important to make sure the timing is right on your cameras—and also on your second shooter's cameras—because during this process you can view the images by "date created" and it will sort everything in to the right order. I make subfolders within this big folder called FULL and name them A, B, C, D, E, F, G, and H. This is how I stay organized and keep everything in a nice sequence. It also helps make everything manageable and helps me to get everything done.

- Folder A contains all of the getting-ready shots
- Folder B contains all of the ceremony shots
- Folder C contains all of the bride-and-groom portraits
- Folder D contains the bridal party shots
- Folder E contains all of the family portraits
- Folder F contains the cocktail hour shots
- Folder G contains the reception photos
- Folder H contains all of the still lifes

The Value of Editing

It is amazing what editing can do for a picture. Simple edits made to a photograph can make a world of difference. Editing photographs can really make your pictures look very professional and stand out from others. Developing a good eye when it comes to cropping, sharpening and color correcting photos is important as a photographer to make your pictures look the best that they can and show your clients in the best way possible. The editing process is a very important aspect of being a professional photographer because editing allows you to alter your pictures to make them look the best that they can.

Uncropped

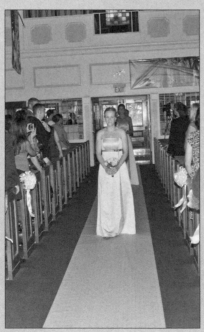

Cropped

I am kind of particular in this sense. I like everything to be in a certain succession; I want the images to tell a story.

Next, I go through each folder, look at the images that I decided to keep, and edit each photo file. When I edit each picture I do three things: crop, color correct, and sharpen.

Editing Each Folder

For editing pictures I use Photoshop. Photoshop helps me to color correct, sharpen, and crop the pictures I have chosen to show the couple. I use Bridge, which works hand-in-hand alongside the program Photoshop to do the rest of the editing process: batch rename, put the photos in the order that I want, and convert to jpeg). I like to use Photoshop because I can do all editing functions with one program. I highly recommend Photoshop for editing images, but an alternative would be GIMP, which can be found at www.gimp.org. This program allows you to edit photos, but you would need a separate program to format them to jpegs, such as Image Converter Plus, which can be found at www.imageconverterplus.com.

Folder A—Getting ready

Pictures in this folder usually take place in a bedroom or hotel room, so they're usually pretty cluttered. I tend to crop out these things the most: electrical outlets, food, laundry, toiletries, wood panels, and extra wall space. If I have to, I'll ask permission to move small pieces of furniture or lamps. These rooms are not built to have a photo shoot in, so you have to work with what you've got. These pictures tend to be shot with a lot of natural light (without a flash), so I have to make them brighter so they pop. I like having my pictures be neutral—not too yellow or blue. Also, I look for any pictures that need to be sharpened.

In this folder I like to make pictures black-and-white and have a lot of contrast. For presentation, I usually do not retouch photos. I will retouch prints and images for albums or upon request, but that is an a la carte item and I charge $75 per image. If I do retouch any images, it is usually cosmetic. I'll brighten eyes, teeth, remove scars, acne, dark circles under eyes, and wrinkles. Also, on the noncosmetic retouch, I'll remove light switches, cords, telephone lines, and poles.

Folder B—The Ceremony

Editing the ceremony is all about cropping people out of the pictures. I'd say I have to crop about 50 percent of ceremony images, which is a lot. Whether it is people in

the bridal party, or guests, or the officiant—I always have to crop people out of the aisle in these shots.

Church photographs tend to have a yellowish tint, so that's something to fix in this folder. The exposure usually needs to be brighter and is something I look for in these pictures. I also take pictures and make them black-and-white, especially if I have two images that are almost identical. I leave one in color and show the client one in black-and-white. If I retouch these pictures it's because 90 percent of the time, when the bride and her father are walking down the aisle, the wedding planner is behind them and in every single frame. Since it's a confined space there are always people that need to be retouched out of these pictures. There may be a lot of random hands in the shots in this folder, so I get rid of those as well. Those guests' hands, ironically, are holding cameras, trying to snap the bride coming down the aisle and determined to get the best angle.

Folder C—The Bride and Groom Portraits

This folder tends to take less time to edit than the others. The cropping that I frequently do is switching a photograph from vertical to horizontal, or the other way around. Or, if the couple is in the distance, I'll crop out some of the excess background. I crop a lot of cars out of photos in this folder. The lighting on this group of pictures is usually right on, so I don't need to do a lot of color correction. Retouching is usually cosmetic, and like I said before, I don't do this unless the couple wants to pay extra for the service.

Folder D—Bridal Party, and Folder E—Family Portraits

These two folders are very similar. It's hard to get a shot with everyone's eyes open and with everyone smiling nicely. If there are a lot of people in the bridal party or the family, you can cut someone out without it seeming obvious, if you have to. The light is usually right on with this folder as well, and retouching is upon request only.

Folder F—Cocktail Hour

You always have to crop pictures in this folder, like the ceremony folder. There are always a lot of random hands in the shots because it's so crowded. And someone's head is always in the background, so you have to crop it out. I usually crop tighter on these pictures, and like to get close-ups of the guests. Because the cocktail hour is usually indoors and the lighting is low, I tend to have to bring the exposure up to make them brighter. If I retouch, it's a lot of hands and exit signs.

Folder G—The Reception

This folder is similar to the cocktail hour. I crop these photographs tighter, and sometimes switch them from horizontal to vertical or the other way around. There is always a mix of different light in these pictures and I always use a flash. There is usually not a lot of color correcting, except for making some shots black and white. Like the cocktail hour retouching, exit signs and hands are popular.

Folder H—Still Lifes

I crop photos in this folder a lot. If the item in the picture looks too big, I get rid of the excess background. I want a tight shot and I want it to be focused. I always use color for these shots, and they're mostly done in natural lighting. I tend to make the exposure brighter in a lot of these photos. I never really retouch any of these photographs, but if I do it's because a tablecloth is wrinkled or if something is out of place.

Converting to jpeg

The third step of the process is to convert the files to jpegs. To convert all of my photos to a jpeg format, I use Adobe Bridge. Bridge has a great jpeg export feature, which allows you to convert any graphic image to a jpeg file. This process does take awhile, but the good thing is you don't have to do each photo individually; you can do all of them at once. This is why I prefer Bridge to any other program; you can do anything you need to in this one program rather than with multiple programs.

I select all and batch rename. I always rename using the bride and groom's last names. Then I take that folder and image process it, so that all the images are jpeg. Once the program batches and creates a folder, I name it with the couple's last names and the wedding date, but instead of FULL I call it FINAL. I put the final folder into another folder called "Projects 2011 final jpeg." Within this folder, I categorize all the jobs into folders created for specific types of jobs, such as headshots, engagements, corporate, weddings, and so on.

After Editing

After I am done editing, I go back to the original folder—in this example named "Smith/Anderson wedding full 7/30/11" and rename it "Smith/Anderson wedding raw 7/30/11." I do this because sometimes a couple will come back and say, "We really like image 005, but it is in color and we'd like to see it in black and white." I can go back, find the image, and adjust it to their liking—it's simple.

> ### What Makes Editing Easier for Me
>
> The process of editing usually takes about three days. If I wanted to get it done in a day I could, but it would be eight hours uninterrupted. You have to be totally focused. I don't like to do it that way because you can't do anything but edit. You can't answer the phone or reply to e-mails, because you'll get distracted and offtrack. Stretching the editing process to three days is perfect for me and my lifestyle.
>
> When I'm editing, I have to listen to music. I can't edit without it. I also like to keep a lot of water near, and protein-rich foods like nuts to snack on. My advice is to come up with a system that works for you and develop rituals that will keep you organized.

After renaming the folder, I take it out of the TO BE EDITED folder. Now I have a copy of the wedding in RAW format and a jpeg copy. I put the jpeg files on my client-proofing website, so that I have three different copies. I delete this file off of my computer after I make sure that it is backed up on two different external hard drives in case I need to retrieve it at a later date.

Client Presentation

Some photographers prefer to meet with their clients to show them the slide show of all the edited wedding images. Some photographers prefer to upload the pictures to a website and let the clients look at their wedding images in the comfort of their home and at their leisure. There are advantages and disadvantages to both. Neither way is right or wrong.

I prefer to upload pictures to a client-proofing website, to let the couple look at their images when they can. To schedule an appointment, make a slide show, and show a couple the images from their wedding takes time. The perks of showing a couple in person is the "woo factor"; it can be emotional and moving. There also is a chance that you will sell more prints this way, which is the highest profit margin. On the other hand, presenting online is more convenient for both parties, and I find that clients tend to prefer it.

Client-Proofing Sites

I work with a company called Pictage and clients can have the capability of ordering prints online right from their home. Pictage is a win-win situation for clients and the photographer. I like Pictage because it offers full services that meet my needs. I order all my prints, proof books, and albums from Pictage, have used this company for all of my jobs for the past six years, and love it.

Not only does the couple have access to view their pictures, but their guests do as well. Having event cards to hand out at the wedding with the URL of the couples' proofing site comes in handy for this. You will see a huge difference in print sales if you pass out event cards. The couple and their guests have the opportunity to order prints from you via Pictage, and print sales have the highest sale margin. Having a turnkey proofing print lab service like Pictage makes life easier, and it's one less thing you'll have to worry about when running your business.

There are many other sites that offer these types of services, or you can design a proofing system and have it as part of your website. I have considered doing this, but don't think I can keep up the fulfillment of the print orders. I prefer to spend my time meeting new clients and photographing them.

12

Wedding Follow-Up and Beyond

Weddings are among the few events a photographer shoots that begin way before the actual day of shooting and go way beyond the actual day of shooting. We already went over the before; let's go over the after.

What a photographer does for "the after" differs greatly. Be as available as you can to completely meet your clients' needs. Act as though their wedding is the only one you need to worry about. This juggling act can be tough, but with experience you learn how to become a pro. Here is a summary of things you may want to do once you are finished shooting a wedding, to fully complete the process.

Thank-You Letter

It is a great practice to send a thank-you letter a few weeks after the wedding. With the letter I include the proof book, the DVD of pictures, and album instructions. I have my own thank-you cards; I used Pictage to design and print them. I include instructions on how to prepare an album, whether the newlyweds included the album or not in their package. Sometimes they'll see it and decide they want it after all. In that case, do a separate album contract and charge them separately for it. A good 50 percent want to do an album from the start, so this is just a way for the other 50 percent to think about it again.

Designing the Wedding Album

Putting together the album can be a really great experience for the photographer and the client. Since every album that I make is completely unique, it is important to involve the client as much as possible to make it personalized. The personal aspect of the album really gets the clients' attention because it is

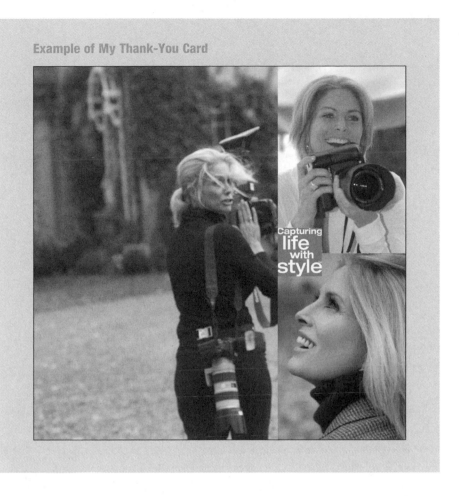

Example of My Thank-You Card

Capturing
life
with
style

totally customizable. The fact that they are in the driver's seat and can control every part of the album makes it really special, which attracts clients to it.

Making an album is a fairly simple process that involves the client more than the photographer. The couple must choose a few different aesthetic options in order to begin album development and get the ball rolling. These three options include the cover material, the font, and the font color. Beyond these, the rest of the album consists of components that the couple chooses. They can choose the pictures they want (they can use the proof book to do this, or they can go online to the client-proofing site); they can choose the text (song lyrics, poetry, or their own prose); they can decide what they want in color and what they want in black-and-white; and they can also choose the order in which everything flows. It is very rare that a couple

This is the album contract I made for couples that want to add an album separately.

Album Contract

Event Date:

Contract Date:

Client:

E-mail:

Type of album:

_____ $ _____

_____ $ _____

_____ $ _____

Deposit: _____ $ _____

Tax:_____ $ _____

Balance: _____ $ _____

Shipping: _____ $ _____

Total Due: _____ $ _____

Terms and Conditions

Image selections and albums: Image selection must be created online by using your assigned Pictage account. An "album" folder will be created by you and the photographer is to be e-mailed the album request and image selection within six months of event date. After creating an album folder, please choose one hundred of your favorite images. Album layout is at photographer's discretion. Additional pages added to albums included with packages will be $75.00/page per magazine style. Upon delivery of album proof, approval or revisions must be submitted via fax or e-mail within thirty days. Further changes or revisions requested by client after initial layout is done will be billed at a rate of $150 per set of revisions, plus $25 for each image, block of text, or graphic altered, revised, replaced, or changed. Your credit card must be on file and will be charged prior to revisions being made. Client's signature required upon final approval. Please allow up to eight weeks for album to be finished. After one year from date of event, album will not be included in any package price.

_____ _____

Client Signature Date

_____ _____

Kristen Jensen Date

Dear:

Congratulations we are very excited about creating your album for you. Here are the instructions and process for creating your album.

1. Visit www.pictage.com
2. Find your event with the event number
 If for some reason your event is expired call the studio office so we may release it.
3. Create a folder entitled: "Your Name" Album
4. Then choose images you would like to see in your album
 Choose images by going through your entire event by categories and choose up to 100 images total. Choose a variety of images from each category that will equal 100 images. This will give your finished album a very storytelling feel.
5. After your initial proof please send photographer an e-mail with specified text, poems, songs that you would like to have included in your album. Such text may be a poem read during a ceremony, or a special prayer, other text could come from your first dance and maybe a funny quote from a speech that was given during the reception. When you send this e-mail please specify on which page/s you would like this text to appear. For example, a poem/prayer read during ceremony should go along with the images from the ceremony.
6. Also, in your e-mail after viewing your first proof, if there are any changes in regards to image placements please include instructions with page/image numbers.
7. After all changes have been made during your proofing process a final proof will be sent to you via e-mail. Along with the final proof of your album an album release form will be sent to you as well, and we will need to receive a copy of the release form before we send your album to be printed. Also, included with your release form please indicate which cover option you would prefer for your album, as well as color and text for embossing on front cover. All album layouts are at the photographer's discretion. Additional pages added to the album are $75.00/page. No outside pictures will be accepted for the album. Upon delivery of second proof via e-mail including all image/outline changes and text addition, which is at a complimentary rate, any changes or revisions requested by clients after the complimentary proofing, will be billed at a rate of $150.00 per set of revisions plus $25.00 each image, block of text or graphics altered, revised, replaced, or changed. Upon delivery of second proof all approvals or revisions must be submitted within 30 days to ensure a timely delivery and to keep the studio up to date on album orders. Please allow up to 10 weeks for album to be finished. The finished product printed and bound will then be shipped to you via Federal Express or you may schedule a time to pick up at the studio.

will tell me to just design the album how I want to. Most of the time, the couple wants to do everything.

I have design software that I use (through Pictage) to make the albums. Using Pictage, you can either choose a template or make your own. After choosing a template, put the album pages in the order that you want. Then add the pictures where they fit best to tell the story of the wedding. Go through the album again and decide what should be in black-and-white, and what to leave in color. Send the couple the link to view the album online.

When the clients look at it, they see the skeleton of the album and can request any changes they want to the layout. Also, at this time, they have the option to add text. I ask that they make a Microsoft Word document of the text that they would like and state the pages they want it on.

The process of making an album varies. I can do the layout in a week if the couple participates actively. It is really up to them—how long it takes for them to decide what text they want, and get back to me so I can add it in. The album takes about eight to ten weeks to be printed. The contract states that clients have to do their album within a year of the wedding. Otherwise couples may come to you years after their wedding to do their albums.

Promoting Your Business

Like I mentioned earlier, the whole wedding process is very long, and doesn't end once you mail the couple the proof book, DVD of photos, and album. There are customary courtesies that you can offer for every wedding that you shoot. These make the client feel special—you want them to know that you appreciate that they booked their wedding with you, and should do everything in your power to let that show. There are also things you can do to market your business after you shoot a wedding, such as contacting vendors that you met at the wedding, which can help build vendor relationships. These customary acts pay off in the end because they help build a strong client-photographer relationship, which goes a long way.

After the wedding is also the time to make friends with local wedding vendors. If you shoot a wedding where there are local vendors you have never dealt with before, send them a letter with photos of their crafts. For example, for a florist, compile all the still lifes you shot of his or her work (flower arrangements for the tables, bouquets, boutonnieres, decorations, etc.), make a disk or a book of the photos, and send

them to the florist with a letter saying how beautiful the flowers were and how you enjoyed meeting them at the wedding. Do this for every vendor that was at the wedding (see the vendor worksheet on page 77 for ideas). Everybody refers colleagues and this small step can bring many new clients to you. It's always better to go the extra mile, especially when you're first starting out.

Anniversary Cards

I like to send anniversary cards to each couple whose wedding I shoot. Doing this once a year for at least five years is a nice gesture and also keeps your name fresh on the couple's minds, in case they have friends getting married who need a photographer, or should they need a photographer for a different type of event. Print a card with their picture on it, write a short message, and send it via snail mail or in an e-mail.

The Next Frontier

I would say for about half the couples whose weddings I shoot, I end up shooting pictures of their kids a few years down the road. Since they booked their wedding with me, they are now part of my client base, so they'll get the e-mail blasts that I send periodically. They will book me for baby pictures, private parties, or corporate events. Everything revolves and clients tend to come back if they need a different service that I offer.

13 Shooting Other Types of Events

A lot of people assume that wedding photographers only work seasonally. Usually this is not true. I have friends who only shoot weddings and do around eighty per year. Unless you live somewhere like Hawaii, or any other wedding destination location, wedding photographers have to find a way to keep a steady income through the whole year, not just wedding season. There are many ways to do this. It is important to keep practicing your skills as a photographer throughout the year so you can gain as much experience as possible. Shooting other types of events can not only build your client base, but also help you to shoot weddings even better.

The experience that you can gain shooting other types of events can help you immensely by exposing you to new situations. Exposing yourself to new events can be invaluable. The good thing about being a wedding photographer is that it teaches you to be able to shoot any other type of event with ease. Shooting other types of events might even feel easy compared to a wedding!

What to Do When Wedding Season Is Over

Most weddings fall between the months of April and November. During these few months you will likely be booked only for weddings. Here and there you may shoot a different event, but especially over the summer months, you will doing at least one wedding every weekend. During the slower months, say between December and early April, when people don't usually book weddings, try to shoot as many other types of events that you can. These types of events include fundraisers, corporate events, black-tie events, golf tournaments, anniversaries, birthdays, and bar/bat mitzvahs.

Booking Jobs to Supplement Your Wedding Photography Income

I am usually booked for other types of photography jobs because of a referral. It is also very common that a client whose wedding I shot will use me for something else, like a corporate event. When you first start out it is important to gain experience with events other than weddings. Volunteer to shoot local charity events: You can submit pictures to local magazines and get a photo credit. You'll get press just from being there and taking pictures of important people in your community. For any type of event you do, it is important to submit those pictures to a local newspaper or magazine to get your name out there in a photo credit. This is a great way for someone looking for an event photographer to see your work.

Corporate and Black-Tie Events

To shoot these two types of events, someone within the company will contact you to hire you. Usually, contact is through phone or e-mail. I have been brought in on meetings but that is very rare. Corporate events are usually booked a couple of months in advance and you don't have to meet with company officials beforehand. Have the company sign the contract, collect the deposit, and follow all the same steps you would for a wedding shoot.

Get to the shoot at least a half hour before the cocktail hour. The rooms are usually really pretty, so take a lot of detail shots. For some events an area in the front of the venue is set up for executives to get press shots taken as they arrive during the cocktail hour. Also, sometimes it will be in the contract that all the pictures taken during the cocktail hour, when everyone is arriving, are to be made into a slide show on the spot so it can be shown during the event. In this case, hire a second shooter to make everything go more smoothly. Try to book the second shooter soon after you book the event. It's a good idea to stay on top of booking assistants and second shooters, to give them enough notice and so that you aren't scrambling around at the last minute trying to find help for an event the next week.

Corporate and black-tie events are very straightforward. There is no emotion involved. Go around, introduce yourself to people, and take their picture. There are usually caterers and other workers running around, so it is best to just blend in. If the event includes a sit-down dinner, be sure to photograph the program. You might want to hire a second shooter if the party is large or there will be speeches. You and the second shooter should be on opposite sides of the room when speeches go on. You can shoot with a long lens and the second shooter can shoot with a flash a little closer to the stage.

Another big difference between corporate events and weddings is that once you say goodnight, it's goodnight; you pack up your stuff and go. The company

usually will need the press pictures rushed for the next day and you have that under contract. The rest is due in about a week, so make a DVD of the pictures and send them to the company. Also, upload everything to your client-proofing site. For bigger events, you can make event cards to hand out to guests. Since I upload pictures to Pictage, people can log on, look at them, and buy prints if they want.

Golf Tournaments and Fundraisers

Golf events and fundraisers can be a lot of fun. It is a great opportunity to meet people and I always feel like I'm doing a good deed when I get involved with charities

Special Event Pricing Structure

My price includes candid shots at preparty, party shots during cocktail hour and dinner, online proofs, complete DVD of all high-resolution images, press photos e-mailed upon request, and a photographer's assistant (second shooter). **$2,000**

Upgrades and Pricing
Magazine Album

12 x 12-inch	$2,500
9 x 9-inch	$2,000
6 x 6-inch	$700

Up to twenty pages/forty sides (one hundred images), bound in choice of leather, suede, or fabric

Traditional Album

10 x 10-inch	$1,700
8 x 8-inch	$1,300
5 x 5-inch	$600

Up to fifteen pages/thirty sides (seventy-five images), bound in leather

Additional DVD of high-resolution images	$1,500
DVD slide show	$1,000
Travel (outside sixty-mile radius of studio)	$100/hr

Custom prints and framing available • subject to Connecticut sales tax

and fundraisers. I love fundraisers because you really get to know more about the charity and it's great to spread awareness. Golf events are also a good way to meet people, and these shoots can be really goofy.

For these two types of events, whoever is in charge will contact you to book the event, and it will most likely be on the phone or through e-mail. Most of the time you don't meet up ahead of time. The contract can be e-mailed or faxed once it's filled out, and the deposit can be mailed to you. You meet the client at the event. It is easier to do these types of events because there is a lot less involved.

During golf events I'm out on the green for six to seven hours. Usually I'll do a slide show during cocktail hour of all the pictures I shoot. For these types of events I'll have three or four second shooters/assistants. One or two second shooters are on the green shooting while another second shooter goes around collecting media cards to start putting together the slide show. We all wear Kristen Jensen Photography polo shirts and colorful sneakers. I try to make these events as much fun as I can. I'll take pictures of the guests in golf carts and pose them drinking beers and being funny. I love getting shots on golf courses because they're so well maintained and a great background for pictures. For these events I also like to get still lifes to add to the slide show.

Anniversary or Birthday Parties and Bar or Bat Mitzvahs

For these types of events, a little more planning is involved. They are more personal. Usually, someone will contact you via phone to hire you, and most of the time a pre-event meeting is involved, just like a wedding. For these four events, plan to make albums and have a separate contract and price list for them. Just like for weddings, meet the party planner or whoever is planning the event to go over every detail of the party, so you know what to expect and know what is expected of you. It is a good idea to be on the same page and to know what the client wants you to do.

Sometimes anniversary or birthday parties are a surprise. Get there early, with all the guests, and take shots of everyone getting ready for the birthday person to come. Surprise events are great because I love to capture the birthday person's expression. A lot of times there will be a theme involved, and you can get some really playful shots.

The most popular event I do besides weddings is either a bar mitzvah or bat mitzvah. The families usually book a photographer one to two years in advance,

because they have to be on the roster for the temple that far in advance. Bar and bat mitzvahs are almost like weddings, and I treat them that way. I have albums, photo books, and slide shows to show parents when they come to meet me to go over details. I have a separate price list and contract for bar mitzvahs and bat mitzvahs that I shoot.

The most high-end parties I've ever shot are bar mitzvahs and bat mitzvahs. These events are usually held at a reception site, just like a wedding. Always have a

Bar Mitzvah and Bat Mitzvah Pricing Structure

My price includes a portrait session at your temple on the event date or up to two weeks prior to the date, unlimited images of portraits and party, online proofing, one DVD of high-resolution images, and a coffee-table proof book. I will be accompanied by a second photographer. **$5,000**

Upgrades and Pricing:
Magazine Album

12 x 12-inch	$2,500
9 x 9-inch	$2,000
6 x 6-inch	$700

Up to twenty pages/forty sides (one hundred images);
bound in choice of leather, suede, or fabric

Traditional Album

10 x 10-inch	$1,700
8 x 8-inch	$1,300
5 x 5-inch	$600

Up to fifteen pages/thirty sides (seventy-five images); bound in leather

Additional DVD of high-resolution images	$1,500
DVD slide show	$1,000
Travel (outside sixty-mile radius of studio)	$100/hr

Custom prints and framing available • subject to Connecticut sales tax

second shooter because it's like two parties going on at once. The parents will have a cocktail party and the kids will be in the next room dancing to the DJ. Because I treat these events just like a wedding, I will book a second shooter up to six weeks in advance and go over details with them.

There are two parts to a bar mitzvah or bat mitzvah. The first is in the temple, shooting the ceremony of becoming a bar mitzvah or a bat mitzvah. Typically, photographers cannot take pictures during the ceremony, and I have even had cases where temples do not let any pictures be taken the day of the ceremony at all. You may have to shoot before the event, and have them reenact the ceremony to get all of the pictures. Sometimes I'll meet with the family and the temple's *kohen* at the temple early to have them reenact the ceremony. This should all be scheduled ahead of time and be in the contract. If you can't take pictures the same day, meet with the family and *kohen* on a completely different day to do the reenactment. I would say this happens for about 50 percent of bar and bat mitzvahs. I have to stage every picture, and in some ways it is easier this way because I get exactly the shot that I want.

The second part of a bar mitzvah or bat mitzvah is the party. The party is usually on the same day of the service, but sometimes there is a lot of time between. Sometimes you only have to shoot the party because you've already staged the ceremony pictures. Shoot family portraits and headshots either on the day of the reenactment or the party. This is a good way to sell the package, because there will be a lot of family portraits being taken. Make event cards for the bar mitzvah or bat mitzvah celebration to hand out to guests. This way, they will be able to log onto the client-proofing site, see the photos you've taken, and order them if they'd like.

Like a wedding, get to the venue early to take still lifes of the room and get detail shots. Like a wedding, try to get pictures of most guests that attend the party. Go up, introduce yourself, and take their picture. There are some money shots that you should be sure to catch:

- Reenactment shots at the temple
- Candle lighting
- Speeches/toasts
- Horah dance (make sure you have a ladder for this!)

Stay until the very end of the party, or pretty close to it. Once you have edited all the pictures and chosen which to show the parents, upload them to Pictage or your client-proofing site. All the guests can go on the site, view the pictures, and order

them if they please. Send a thank-you card to the parents, along with the DVD of pictures and album instructions. If the parents order an album, do the layout and send the URL to the parents to take a look at. After they send a word document of the text they want in the album, make the changes. In ten weeks, the album will be delivered to the family in the mail.

Portraits

The more you shoot, the better photographer you become. I tell my new assistants and second shooters that the only way to learn is to keep on clicking and trying different light, lenses, subjects, and locations. Portraits are a great business because just about everyone, at some point in their lives, needs a professional photo. To supplement my off-season, I fill my calendar with portraits. I enjoy the break from wedding photography, and portraits can be very fun to shoot. The nice thing about portraits is that they are quick and you can really personalize them and make them exciting. Portraits are also good practice for the portraits you shoot on a wedding day. See the sample portrait brochure on pages 152–153 for ideas and pricing options.

How to Shoot Portraits

I almost always use natural light in my portrait photography. I also use reflectors to reflect natural light. I mostly shoot in my studio. I open up my home to shoot in as well, so that portraits look more environmental and more lifestyle-like. I don't just do head shots. I like to shoot three-quarter shots, and I use every angle

Breakdown of the Main Portraits I Shoot

Besides shooting really elegant weddings, a huge part of my business from Monday through Friday is shooting portraits. Listed below are the types and the percentage of portraits I shoot.

- Family and Children Portraits: 25 percent
- Corporate Business Portraits: 50 percent
- High School Senior Portraits: 25 percent

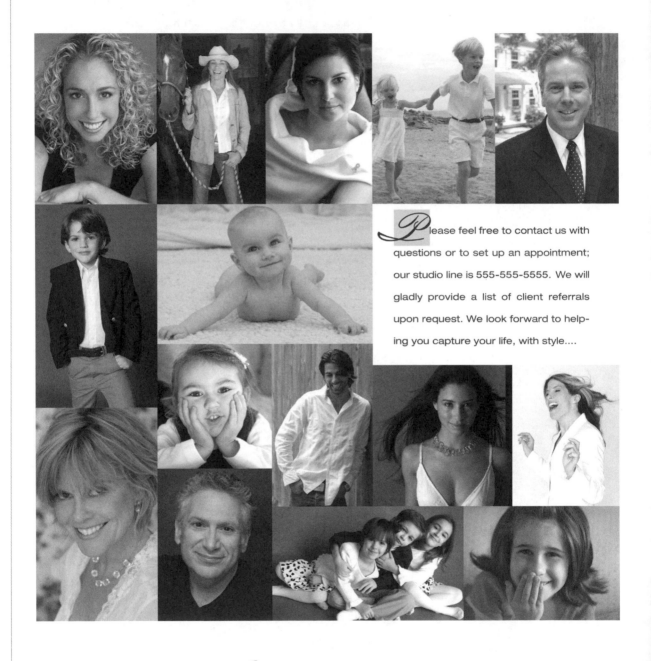

*P*lease feel free to contact us with questions or to set up an appointment; our studio line is 555-555-5555. We will gladly provide a list of client referrals upon request. We look forward to helping you capture your life, with style....

d y n a m i c
portraits

KRISTEN JENSEN
PHOTOGRAPHY

People have said that I have a gift for putting my clients at ease in front of the camera. This results in dynamic photos that reflect the true spirit of my subject whether it be an infant, a child, a teen, a family, a professional or publicity portrait.

555.555.5555

www.kristenjensen.com

family & children
- **a-day-in-the-life photo session** ...$1,850
 includes: 7x7 proof book, one 11x14 b&w print
- **photo session on location**...$850
 includes: 5x5 proof book, one 8x10 b&w print
- **studio photo session** ..$600
 includes: two 5x7 b&w prints

professional/publicity
- **studio photo session** ..$600
 includes: two wardrobe changes, two retouched hi-res digital images
- **photo session on location**...$850
 includes: two wardrobe changes, two retouched hi-res digital images,
 two 8x10 color prints of same
- **corporate group packages available**priced accordingly

yearbook
- **photo session** ..$300
 includes: image submission to yearbook, two wardrobe changes, $50 print credit

makeup artist available..upon request

5x5 proof book (up to 100 photos) ..$200

7x7 proof book (up to 100 photos) ..$300

custom framing & matting available...............................priced accordingly

print pricing

	first	additional of same
4x6	$10.00	$5.00
5x7	$15.00	$7.50
8x10	$25.00	$12.50
11x14	$50.00	$25.00
16x20	$62.50	$31.25
16x24	$70.00	$35.00
20x24	$75.00	$37.50

prints on canvas

11x14	$125.00
16x20	$140.00
16x24	$150.00
20x24	$175.00

online proofing included ▪ subject to Connecticut sales tax ▪ subject to change

possible. I change the background and move my subjects around, trying to get as many looks and backgrounds as possible in one shoot. My favorite lens is my Canon 85 mm, which is a medium telephoto lens that is ideal for portraits and natural images.

Shooting Family Portraits

Shooting family portraits is really fun, but definitely takes practice. Trying to get young children to smile nicely, or get two or three to look at the camera at the same time, can be challenging. But I adore photographing children and I find the challenge exciting, no matter where the location is or the mood of my subjects. Little people require that they trust you. Bring along a stuffed animal or a lollipop. Try to advise the parents on wardrobe beforehand and discuss location. Shoot at a nearby beach or park because of the picturesque backgrounds they provide. The profit margin on shooting family portraits is the greatest of all my photography. I typically make the most money from the print, framing, and holiday card orders. Be prepared to take anywhere from 350 to 750 images per family shoot.

Shooting Corporate/Business Portraits

Shooting corporate and business images are great fun, too. These are most often shot at your studio, if you have one in your home. If not, you can rent space. Have a top makeup and hair person on set for female clients. This sets the mood for the shoot and the clients feel pampered and relaxed. Even guys sometimes want a trim or shave the day of a shoot. I very often do a Skype interview prior to the shoot to go over wardrobe and hair. Work with your client's vision and what they are selling. If you are working with a web designer, use wardrobe colors to match their site.

The profit margin is not as great as a family portrait session because the client only needs one or two great digital jpeg files from the shoot. However, these types of shoots are easy because you can do them from your home studio and you also get to build your client database. I had one client come to me for business headshots because she was a local realtor. She then recommended her actor son to me for headshots, and then later referred me to her daughter to shoot her wedding. You never know what referrals you will get from shooting different types of sessions, which is why it is so beneficial to offer these types of shoots.

For a business portrait shoot, take about 250 images.

Shooting High School Portraits

I could almost shoot high school portraits blindfolded. First, the kids are young and hip, and you can easily have a lot of fun with them to put them at ease. The clients again come to your home-based studio (if you have one), and the shoot is done within thirty minutes to an hour, depending on how many wardrobe changes they need. I charge less for these shoots because I can do more in one day and they are fun and easy. Again, many of the parents of high school clients need family or business portraits, so it is nice to meet them in person and show them your other types of work as well. Take between 125 to 150 images per shoot. Here are a few things to keep in mind when shooting senior portraits:

- All senior portraits are photographed digitally.
- All proof images should be available online within two weeks from shoot date.
- All print orders are to be made online.
- Yearbook photo selection is to be e-mailed to the photographer at least two weeks prior to the yearbook deadline; the photographer will send the selection to the yearbook staff at the client's high school.
- Professional hair and makeup for all portrait shoots are recommended; additional $50 fee, payable by separate check, should be charged.
- Ask clients to bring clothes in colors other than black or white. Bring an assortment of seasonal clothes, including shoes. Have clear nail polish on toes and fingers.
- A copy of the entire shoot should be available on CD if requested for an additional fee ($179).
- Tell the client the shoot will take an hour; he or she should bring an iPod.
- The shoot will be at the photographer's studio, or on location for an additional fee.
- Portrait packages do not include state sales tax.

See page 156 for a sample of my senior portrait package pricing.

senior portrait session • price list 2010-2012

- All senior portraits are photographed digitally.
- All proof images are available online within two weeks from shoot date.
- All print orders are to be made online.
- Yearbook photo selection is to be e-mailed to photographer at least 2 weeks prior Yearbook deadline; we will send your selection to the yearbook staff at your high school.
- Professional hair and makeup for all portrait shoots recommended; additional $50 fee payable by separate check.

- Please try to bring clothes other than black or white. Bring an assortment of seasonal clothes including shoes. Please have clear nail polish on toes and fingers.
- A copy of the entire shoot will be available on CD if requested for an additional fee ($179.00).
- Shoot will take an hour; bring your iPod.
- Shoot will be at photographer's studio or on location for an additional fee.
- Portrait packages do not include state sales tax.

Name: _____

Address: _____

E-mail: _____ (work) _____

Phone: (home) _____ (cell) _____

Whom should we thank for referring you to us? _____

Shoot date: _____ time: _____ Rain date: _____ time: _____

Silver Package: Includes 36-50 exposures, 1 look.
Prints are to be ordered online; shipping payable by client.
Yearbook submission by photographer.
...$199.00

Gold Package: Includes 36-50 exposures, 2 different looks
Print credit of $20.00 issued online.
Prints are to be ordered online; shipping payable client.
Yearbook submission by photographer.
...$299.00

Platinum Package: Includes 36-75 exposures, 3 different looks
Print credit of $40.00 issued online.
Prints are to be ordered online, shipping payable by client.
Yearbook submission by photographer.
...$399.00

Total: Sales tax (6%) $_____
Subtotal ... $_____
TOTAL -------------------------------- $ _____

Payment information: (Make checks payable to Kristen Jensen Photography.)

Payment by Check Deposit check #: _____ amount: _____

Final check #: _____ amount: _____

Acceptance of terms: Please sign, date, and fax or mail with 50% reservation and fee to

Kristen Jensen Photography, 123 Main Street, Any Town, CT USA

Signature: _____ Date: _____

E-mail Address: _____ Cell: _____

Meeting with the Client and Signing a Contract

Sometimes I meet a client ahead of time for portraits, but mostly these are scheduled over the phone. There is usually no "sealing the deal" with portrait photography. If a client comes to you, they are usually looking to book, not to meet with several photographers like wedding clients. Like I mentioned, sometimes I will talk with a client over the Internet on Skype, which is very convenient. But I don't necessarily need to meet with a client, so the phone is fine. There isn't really a benefit to meeting with a client beforehand, other than to get acquainted with one another.

Use the same procedure for getting a wedding contract signed: Send it in the mail with two copies: one that they keep and one that they sign and send/fax back. Have a contract for each portrait shoot, and require a 50-percent deposit to hold the date. When booking the date make sure to have an extra date on the calendar as a rain date, and go over this with the client. Shooting portraits is nice because if the weather is not ideal you can reschedule, unlike weddings and events. Portraits are a lot more flexible.

Benefits of Shooting Other Types of Events

The benefits of shooting other types of events are endless. They can be great learning experiences as well as good ways to meet prospective clients. It is a great idea for a wedding photographer to branch out and do other types of events. By offering events other than weddings, you can expand your business as much as you want. Volunteer at charity events or fundraisers, even as an established photographer, because you never know who you will meet or what photo opportunities will arise.

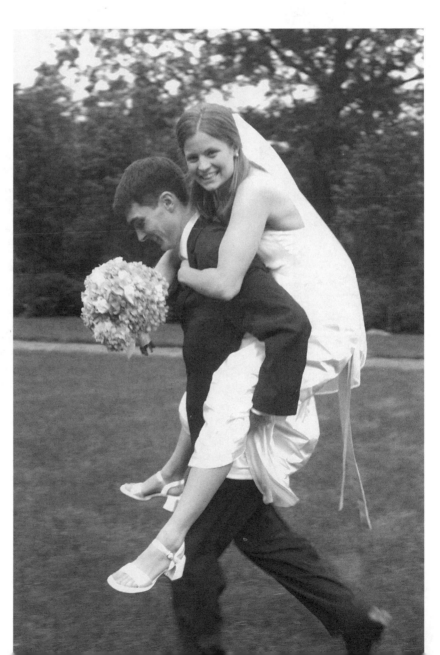

Getting Ready: With Bride

Getting Ready: With Groom

Ceremony

Formals:

Reception:

Appendix B: Sample Contract

The following contract sample is for reference only. The legal information contained in this document and throughout the book are provided for informational purposes only. Readers are advised that the content contained herein is not a consultation, recommendation, nor legal advice regarding any particular matter, situation or circumstance by the author or publisher. If you feel you need legal advice, please consult an attorney in your jurisdiction.

KRISTEN JENSEN PHOTOGRAPHY

123 Main Street • Any Town, CT USA

tel 555.555.5555

www.kristenjensen.com

wedding photography contract

Date of Contract: **Wedding Date**: **Est. # of guests:**

Client contact information (party responsible for payment)
Client name:
E-mail:

Billing address:
Phone (h): **Phone (w):**
Cell:

Bride's name:

Groom's name:

Photographer's initial arrival on day of event (pre-ceremony): time:
Location/address:
Alternate location/address:

Ceremony: **time:**
Location/address:
Alternate location/address:

Formal portraits: ☐ **pre or** ☐ **post event** **time:**
Location/address:

Reception: **time:**
Location/address:

Engagement session at photographer's studio: Included in package price: ☐ **Yes** ☐ **No**
Date: **time:**

Explanation of Time and Breaks

Each package price includes an amount of time specified in the descriptions on page one of this contract. Photographer's time begins upon her arrival and ends by the clock at departure, regardless of travel time, etc. (For example, if your package includes 8 hours and the photographer arrives at noon, her contracted time will end at 8:00 p.m.) Time exceeding the specified amount will be billed at $250.00 per hour. Please note that the photographer and assistant(s) will take a short meal (to be provided by client) break when all guests are seated for the meal and the toasts have been made. Please make arrangements for a meal and place for it to be eaten.

The package fee is based on the Photographer's Standard Price List on the pages herein and includes the photographs described herein. If the fee is not based on a package but is a session fee, all photographs shall be billed in addition to the fee and in accordance with the Standard Price List. In addition to either the package fee or the session fee, the extra charges set forth on the following pages shall be billed if and when incurred.

Deposit schedule: 50% due upon signing event contact, payable by cash or check.

Next 25% is due 60 days prior to event.

Balance is due 30 days prior to event.

If the client decides, for any reason after signing contact, not to use Kristen Jensen Photography to photograph the event the client will lose the entire initial deposit paid to date.

In the event that Kristen Jensen is unable to shoot for any reason (medical, accident or otherwise) and notifies the client in writing no less than 30 days prior to event date, the client will be refunded their deposit and provided with a list of comparable photographers for replacement. In the event that Kristen Jensen is unable to shoot for any reason (medical, accident or otherwise) and notifies the client within less than 30 days of clients event date, Kristen Jensen Photography will provide documents necessary to client and will arrange to have a competitor or colleague of comparable photographic performance and quality, accompanied by Ms. Jensen's assistant, present on event day.

Fee: $

Options

Albums: $

Subtotal $
Sales tax $
Total due $
Amount of 1st deposit (due by) $
Amount of 2nd deposit (due by) $
Amount of 3rd deposit (due by) $
Balance due $

The parties have read all pages of this Agreement, agree to all its terms, and acknowledge receipt of a complete copy of the Agreement signed by both parties. Each person signing as Client below shall be fully responsible for ensuring that full payment is made pursuant to the terms of this Agreement. All payments must be made before photos will be supplied.

Client:_____ **Date:**_____

Client:_____ **Date:**_____

Photographer:_____ **Date:**_____

This Agreement is subject to all the terms and conditions appearing herein.

Terms and conditions

1. Exclusive Photographer. Kristen Jensen Photography shall be the exclusive photographer retained by the Client for the purpose of photographing the event. Family and friends of the Client as well as Videographers shall be permitted to photograph the event as long as they shall not interfere with the Photographer's duties and do not photograph poses arranged by the Photographer.

2. Deposit and Payment. The Client shall make a deposit to retain the Photographer to perform the services specified herein.

 Deposit schedule: 50% due upon signing event contact, payable by cash or check.

 Next 25% is due 60 days prior to event.

 Balance is due 30 days prior to event.

3. Cancellation. If the Client shall cancel this Agreement after signing the client will lose their entire deposit.

4. Photographic Materials. All photographic materials, including but not limited to negatives, transparencies, proofs, and previews, shall be the exclusive property of the Photographer unless a DVD of high resolution images are specified for the client in the contract. If client is to receive a DVD of negatives, then Kristen Jensen Photography at time of delivery of such product will include a "copyright-transfer" form allowing the client to own the rights to the images and make prints. The Photographer shall make proofs and previews available to the Client for the purpose of selecting photographs. The Photographer may, with the Client's permission, make the proofs available on a Web site, CD-ROM or contact sheets. The Photographer will keep the photographic material on file for 24 months from the event date. The Photographer is not responsible for providing clients wit any images, prints or albums after 24 months from the shoot date.

5. Copyright and Reproductions. The Photographer shall own the copyright in all images created and shall have the exclusive right to make reproductions. If the client has the DVD negatives included in contract then photographer will authorize a "copyright-transfer" to be issued to the client. The Photographer shall be able to make reproductions for the Client or for the Photographer's portfolio, samples, self-promotions, entry in photographic contests or art exhibitions, editorial use, or for display within or on the outside of the Photographer's studio, website, advertising and website blog. If the Photographer desires to make other uses, the Photographer shall not do so without first obtaining the written permission of the Client.

6. Client's Usage. The Client is obtaining prints for personal use only, and shall not sell said prints or authorize any reproductions thereof by parties other than the Photographer. If Client is obtaining a print for newspaper announcement of the event, Photographer authorizes Client to reproduce the print in this manner. In such event, Client shall request that the newspaper run a credit for the Photographer adjacent to the photograph, but shall have no liability if the newspaper refuses or omits to do so.

7. Image selections and albums. Image selection must be created online by using your then assigned Pictage account. A "album" folder will be created by you and then emailed to the photographer within six months of event date. Please after creating an album folder, select 75-100 of your favorite images. Album layout is at photographer's discretion. Additional pages added to albums included with packages will be $75.00/page per magazine-style. Upon delivery of album proof approval or revisions must be submitted via fax or email within 30 days. Further changes or revisions requested by client after initial layout is done will be billed at a rate of $150.00 per set of revisions plus $25 each image, block of text or graphic altered, revised, replaced or changed. Your credit card must be on file with us and will be charged prior to revisions being made. Client's signature required upon final approval. Please allow up to 8 weeks for album to be finished. After one year from date of event album will not be included in any package price. _____

8. Failure to Perform. If, within 30 days of the event, the Photographer cannot perform this Agreement due to a fire or other casualty, strike, act of God, or other cause beyond the control of the parties, or due to Photographer's illness, then the Photographer shall either (1) provide documents necessary to client and arrange to have a competitor or colleague of comparable photographic performance and quality, accompanied by her assistant, present on event day, or (2) the client shall be refunded their deposit and provided with a list of comparable photographers for replacement. This limitation on liability shall also apply in the event that photographic materials are damaged in processing, lost through camera malfunction, lost in the mail, or otherwise lost or damaged without fault on the part of the Photographer. In the event the Photographer fails to perform for any other reason, the Photographer shall not be liable for any amount in excess of the retail value of the Client's order.

9. Photographer. The Photographer may substitute another photographer to take the photographs. In the event of such substitution, Photographer warrants that the photographer taking the photographs shall be a competent professional. A meal and a 20-minute break in which to eat it are to be arranged for and provided for photographer and assistant during the reception meal service.

10. Inherent Qualities. Client is aware that color dyes in photography may fade or discolor over time due to the inherent qualities of dyes, and Client releases Photographer from any liability for any claims whatsoever based upon fading or discoloration due to such inherent qualities.

11. Photographer's Standard Price List. The charges in this Agreement are based on the Photographer's Standard Price List. This price list is adjusted periodically and future orders shall be charged at the prices in effect at the time when the order is placed up to a period of 12 months. Client is responsible for all shipping and handling costs incurred in conjunction with any aspect of the work performed.

12. Arbitration. All disputes arising under this Agreement shall be submitted to binding arbitration. The arbitration award may be entered for judgment in any court having jurisdiction thereof. Notwithstanding the foregoing, either party may refuse to arbitrate when the dispute is for a sum less than the amount of the retail value of the Client's order.

13. Miscellany. This Agreement incorporates the entire understanding of the parties. Any modifications of this Agreement must be in writing and signed by both parties. Any waiver of a breach or default hereunder shall not be deemed a waiver of a subsequent breach or default of either the same provision or any other provision of this Agreement. This Agreement shall be governed by the laws of the State of Connecticut.

Editing Steps

Here is a checklist that I made for myself when editing photos from a wedding. I like having a step-by-step checklist because even though I can do this work on autopilot, I have forgotten to do things before and this is a way to avoid that.

1. Take all of the numbered media cards shot at the wedding and use a card reader to download the images to a master folder called UNEDITED JOBS.

2. Create a new folder within the UNEDITED JOBS folder using the bride and groom's last names and the month and year of the wedding. Add the word FULL to the folder to keep organized and know these photos are unedited. This may take some time if you shot in RAW format. Use a program called Image Capture to download files into folders. It makes the process easier and much faster.

3. Once all images shot at that particular wedding are downloaded (including those shot by the second shooter), make a copy on a separate external drive. Again, this may take some time if you shot in RAW format.

4. Burn all the images from the folder to DVDs or onto yet another separate external drive. Whichever the case, make sure you have three copies of the entire job saved.

5. Go through the images using Adobe Bridge to make sure all photos that were shot are downloaded and saved, and that all the "money" shots (e.g., ceremony, bride and groom portraits, first dance) are downloaded. Do this before reformatting media cards.

6. Create eight folders with the category names as listed below (make sure these folders are within the master wedding folder):

 - A: Getting Ready
 - B: Ceremony
 - C: Bride and Groom Portraits
 - D: Bridal Party
 - E: Family Portraits
 - F: Cocktail Hour
 - G: Reception
 - H: Still Lifes

7. Start culling photos from the entire folder. Delete any images that are out of focus, too under/overexposed, and all unflattering images of subjects.
8. Place the images in the specific folders created in step 6. Every image has a place to go in one of the eight folders.
9. Once the entire master folder is edited with files deleted or placed in their correct folders, start to edit folder A. Sequence the entire wedding as it was shot.
10. In folder A, select all and then sort by the "date created," which sorts by the time in which the images were shot. (It is important to make sure that not only all of your cameras are timed and dated correctly, but that your second shooter's are too.)
11. After the computer software has sorted the time sequence, go through a very "tight-edit." Make sure all the images are in sequential order, then color correct and crop. Make some of the images black-and-white.
12. Treat each folder as if it is the only part of the day the client will see. Make sure the folder looks perfect going to "select all." Batch rename the entire folder. (For example, I rename this folder "A-gettng-ready_001.CR2" (CR2 is a Canon file extension for RAW). Do not make these images jpegs yet.
13. Repeat steps 9 through 12 for each folder.
14. Once all eight folders are perfect, select all and copy the images into the master wedding folder. Delete the "A-getting ready folder" and so on. Always make sure that your edited pictures are all in the FULL folder before deleting anything.

15. After I can see all of the edited images starting with A-Getting Ready made it into the FULL folder. I select all and batch rename the entire job folder. Batch rename using the bride and groom's last names followed by the number 001. It looks something like this: smith_jones001.CR2

16. After the files are all renamed, go to Image Processor in Adobe Bridge and select the command that reformats all files as jpegs. This typically takes about an hour and half to process approximately 800 files.

17. After the RAW files have all been converted to jpeg versions, save several copies of the jpeg versions onto the external hard drives. Burn a copy of the images for the bride and groom (if the DVD was in their package). Upload the entire folder to the couple's online gallery at the client-proofing site.

18. Take the edited RAW folder and rename it with the bride and groom's name and the word RAW. Save the edited RAW folder to an external drive, and then delete what is left in the UNEDITED folder that you created in step 2 so that you know it has been edited and you are done with that step.

Index

About the Author

As an artist, Kristen Jensen attributes the modern, candid style of her lifestyle photo assignments and wedding photography to her vast experience in the fashion modeling industry. Her years in front of the camera as an international model with Ford Models provided her with a wealth of knowledge as she transitioned to the other side of the lens. The transition was made with ease and an exceptional eye for detail.

As a result of years of international travel to elegant locations and experience assisting some of the top fashion photographers in the industry, Kristen's passion for photography and editorial style was created and developed. She specializes in portraits of celebrities, artists, business professionals, children, and families, as well as high-end weddings in greater Fairfield County, Connecticut, New York City, and beyond. She has also shot in many "destination wedding" locales.

She is a contributing photographer for *Ridgefield Magazine* and *Bedford Magazine*. One of her recent lifestyle assignments in the Amish Country in Pennsylvania was featured in *SWISS AIR* magazine.

Her wedding photos can be seen in *Modern Bride, The Knot,* and *Grace Ormonde Wedding Style* magazines.

Kristen supports many local charities, foundations, and organizations through her philanthropic work. She has worked with the Susan G. Komen for the Cure Foundation, Kids in Crisis, and Teen Talk Ridgefield, Autism Society of America, Danbury Women's Center, Danbury Hospital, Ridgefield Playhouse, Ridgefield Symphony Youth Orchestra, ROAR (Ridgefield Operation for Animal Rescue), and Founders Hall of Ridgefield.

She is a member of both the Ridgefield and Danbury Chambers of Commerce, as well as the Advertising Photographers of America (APA), the Professional Photographers of America (PPA), and the National Association of Photoshop Professionals (NAPP).